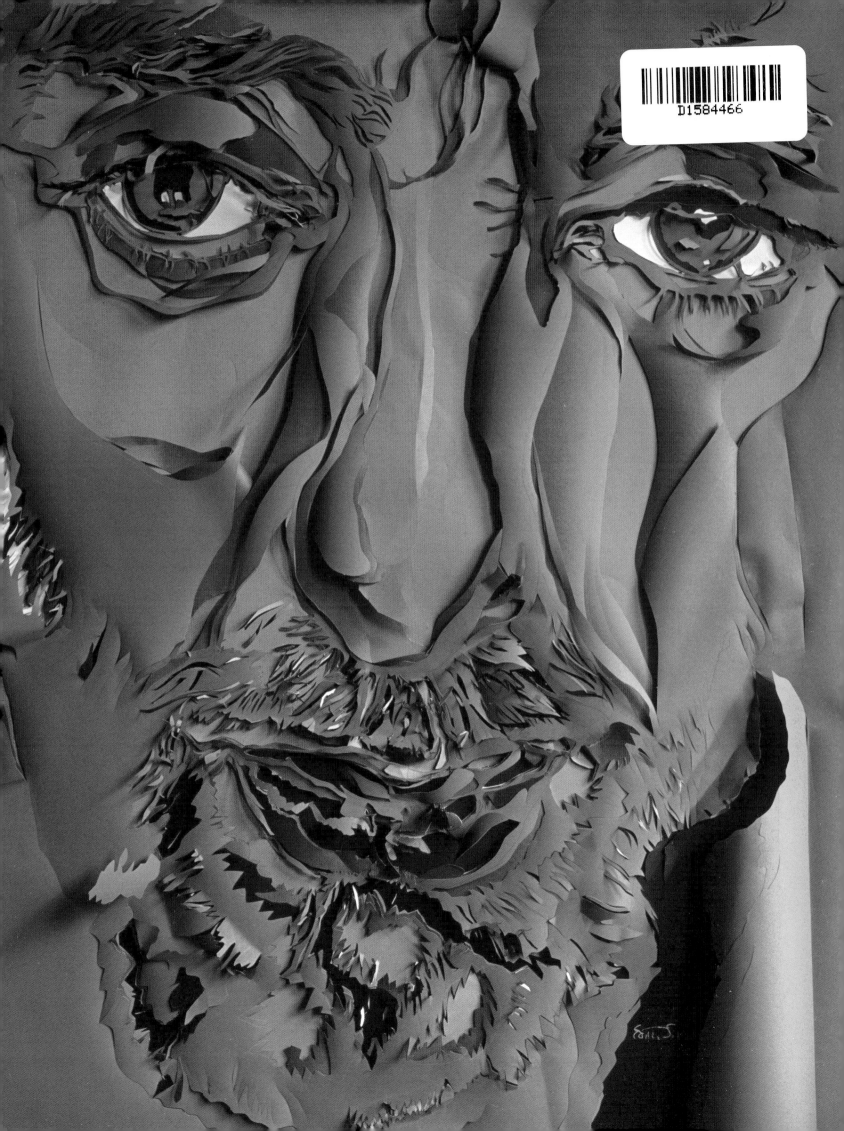

MODERATION BE DAMNED!

edith simon

INGE GOODWIN
GILES SUTHERLAND
ANTONIA REEVE

FOR ERIC
PARTNER AND FAN

Inside front cover: Working on Crucifixion: An Alternative Scenario
Outside back cover: Edith in her studio, working on Dreams of Africa
Page 1: Bluebeard (Trevor Yerbury) 1994 scalpel-painting six colour layers 50 x 41 ins

Published in 2005 by Antonia Reeve

Antonia Reeve
Edith Simon Studio
11 Grosvenor Crescent
Edinburgh
EH12 5EL
Tel/fax: + 44 (0)131 337 4640
Email: info@edith-simon.com
www.edith-simon.com

British Library Cataloguing-in-Publication Data
A catalogue record for this book is available from the British Library.

ISBN 0-9549838-0-7

Photographs of Edith Simon works by Antonia Reeve
Copyright © Antonia Reeve and individual contributors, 2005

Designed by David Faithfull/Semper Fidelis
Production by Neville Moir
Edited by Alison Rae
Manufactured in Spain by Santamaria

CONTENTS

PREFACE

Giles Sutherland has commented on Edith Simon's work, 'Edith Simon's life brilliantly encompassed a number of careers: book illustrator, graphic artist, novelist, historian, translator, essayist, painter, sculptor and draughtswoman. Her output was prodigious and prolific – her career as a writer alone would have satisfied more modest talents.

In her late forties she turned from writing full-time to making art, an occupation that again turned out to occupy her time and talents fully. A catalogue of nearly nine hundred extant works in a wide variety of media testifies to her passionate dedication to developing her art. Satire, levity, and a mischievous sense of humour were all effective weapons in Edith Simon's artistic armoury.

Her annual Festival Exhibitions were a central part of many people's experience of Edinburgh.

Her constant curiosity about materials meant that at junctures in her career Simon experimented with different and ever more challenging media. The use of rope to create sculpture and the use of a scalpel and paper to create 'paintings' are two areas in which her success was marked. Both techniques were innovatory and the latter, in particular, Simon made them her own.

In time, this technique, with all the exciting possibilities it threw up, may come to be seen as being as revolutionary as the use of collage in the early twentieth century. Simon successfully bridged the art-craft divide, creating a synthesis uniquely her own.

This artistic success was not only predicated on the innovatory use of materials but, also, because of her very considerable talents as an artist. Her strengths lay not just in the surface layers of her work, but also deep below based on the accumulated experience and mastery of colour, drawing and perspective.'

We would like to thank Inge Goodwin, Giles Sutherland and Alice Strang for their contributions and help in making this book possible. We would also like to thank Ron Anderson and Myra Malcolm for their energy and commitment, and Alison Rae, without whom this book would not have happened.

Antonia Reeve

Ausser ihrer Grausamkeit sind sie Menschen furchtbar unmu =
sikalisch ; sie gröhlen immerfort Lieder, aber so, dass
man Bauchweh bekommt - und was für Lieder ! Vom Mai sin -
gen sie : -- " Oh wunderschöner Monat Maiiiii " und dabei ist ihr"Maiiiiii"
garnicht so schön, der Juni ist viel schöner, weil er --- viel mehr Libellen,
Mücken, Regenwürmer hat ! Nicht ?! - Und neulich sagten sie, als wir grosses
Konzert abhielten - " quackerackkerekkekekeeckecks " " Pfui ! " Wie findest Du
das ? - Vorgestern hatten wir eine Begegnung, die
unserer kleinen Schwester Quackarinchen das Le- ben
kostete; wir trafen nämlich Herrn S t o r c h, dem
stach Quackarinchen ins Auge, er fasste sie und- ob-
gleich sie sehr zappelte, verspeiste er sie !Wir flo=
hen undals ich zu Hause furchtbar weinte, sagte Paqua gleichmütig : " Was weinst
Du denn so ? , wir haben schon viele Kinder auf diese Weise verloren. Reg' Dich
doch nicht so auf, Kind, iss lieber Deinen Libellenkuchen !
fix ! Quack !" - Na, der muss's ja wissen, nicht ?
Und nun kommt 'was ganz doll Schönes, nämlich ich bin
B r a u t !! Denke doch bloss, Tante Schildkröte, Braut bin ich, - ist Deine Nich=
te jetzt ! - Ist das nicht schön ?, nicht herrlich ? Mein Bräutigam,Quareck von
Rexa, ein feiner Kerl, ist sehr hübsch, gut und reich. Paqua freut sich sehr.-
Montag heiraten wir.-
Viele Grüsse von Quareck und mir

 Deine Nichte

 Quaranka Kasskeksquo

 bald von R e x a

EDITH SIMON

by inge goodwin

Will there be anything else?

Two Soldiers
Hugel 1924 oil painting
60½ x 31½ins

My friend in the street
(and second version)

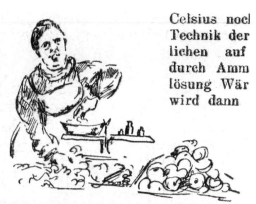

Steht noch etwas zu Diensten?

Edith Simon (13 J.), Wilmersdorf

Newspaper illustrations: ages 13 and 14

Edith Simon (14 J.) in Berlin zeigt die
graziöse Haltung einer Balleteuse. Gra-
ziös — aber auch praktisch? Und Werner

Graceful pose

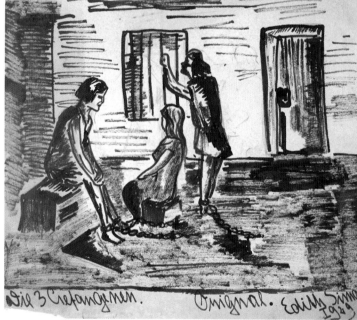

bei den Kleinsten

rippe in Tempelhof wurde von der Stadt ein
t, das bei den Kleinen großen Beifall findet.
le spielte, stand
dicht vor dem Edith Simon
ute unentwegt (13 J.)
m ein anderes
merkwürdigen
r zu besehen,
um nur ja den
Immer wieder
agenden Onkel,
ach im Kasten
b er die Decke
ch, ob er viel-
Wir haben alle
sah putzig aus.
, Mariendorf,
aße 35

Three friends

Three prisoners 1929 pen and wash 8 x 10ins

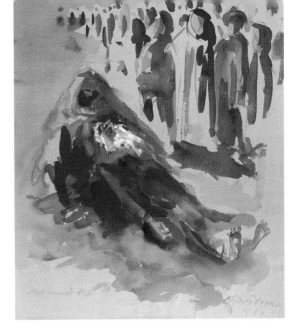

Death 1932 watercolour 9 x 8ins

EDITH SIMON
by inge goodwin

Inge Goodwin is Edith's younger sister, born six years after Edith in 1923.

'Moderation be damned' was my sister Edith's favourite motto, and imagination, daring and excess marked her creative life throughout. When people said to her, as people do, 'You can't have everything', she replied, only half-jokingly, 'I don't see why not.' All her life writing and visual art went together. What she read and what she wrote influenced her art; and the art she saw and the art she created influenced her writing. Only for the last thirty years did art completely take over. By then she had probably written all she most wanted to say in words, while she would never be able to make all the pictures, sculptures and projects she visualised. However, she had a good shot at it: almost nine hundred works are listed, not including many early ones. At exhibitions – she always liked to sit in at her own, observing – interaction with the spectator was immediate and in itself creative. That stimulus hardly ever came from a reading public she never met. Fan letters and reviews were not quite the same and, as she said, more in humour than in sorrow, 'My friends do not read my books.' Indeed, even to some of her friends, and certainly to many who appreciated her as an artist, her long and fine career as a writer came as a surprise.

Edith Simon was born in Berlin on 18 May, 1917. Our ancestors had lived in Germany, mainly in and around the Rhineland, for centuries. Edith's talent and desire for expression surfaced early: a Berlin newspaper published her drawings and serial stories (her earliest hero was a frog) from when she was only ten. She was not particularly happy at home. It was the amiable practice of the middle classes, on the continent as in Britain, to turn their children over to nurses or nannies. Our long-term nurse, a very intelligent and in many ways admirable woman, treated Edith with consistent repression 'for her own good'. We did not really get to know and like our parents until we lived in London.

Chinese recipe book illustration
gouache 10 x 2ins

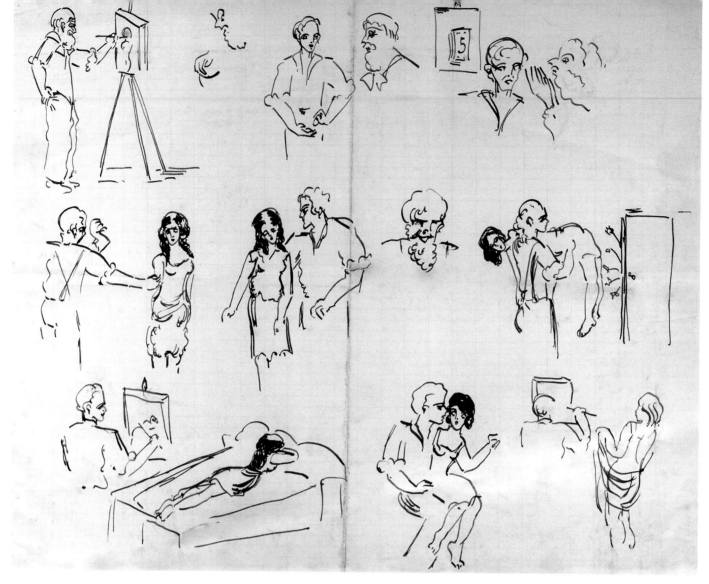

The model 1930s ink 8 × 12ins

Chinese recipe book illustration 2 gouache 3 × 4ins

This situation is explored in the figure of the old nurse Fricka in Edith's novel *The Sable Coat*.

School, on the other hand, the Fürstin-Bismarck Gymnasium, was a place where exciting things happened all the time. The varied personalities of teachers and classmates (the latter included Hilde Litthauer who became Hilde Himmelweit, the psychologist, and Charlotte Salomon, author of *Leben Oder Theater*, a pictorial autobiography), imaginative games, telling stories, painting scenery for school events, and writing essays for herself and all her friends gave Edith immense scope. Her best subject, apart from art, was always history. She received a very good liberal education, until 1932, at which point we moved to England where our parents had emigrated the year before. The political and economic situation in Germany was deteriorating. Over the next few years (the period when the Nazis were actually in power lasted only twelve years) Jewish families like ours which had for centuries considered themselves totally German were forced to emigrate to avoid persecution. Our father, a cheerful pessimist and helped by his talent for languages, was simply the first to size up the situation.

Not all the huge furniture of the Berlin apartment came with us to London, but what did come were the important

AIA Committee as Edith would have done it in 1983
oil painting 36 × 36ins

AIA Committee reconstruction 1983
oil painting 36 × 36ins

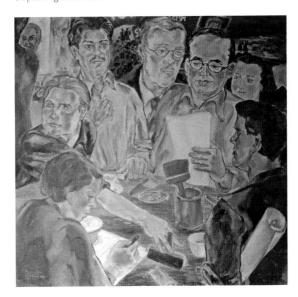

influences – the books, German and Scandinavian classics, translations of Tolstoy and Shakespeare, and the paintings, including some good modern ones.

Emigration, whatever the circumstances, is often felt as an irreparable loss and deprivation, but for us biculturalism meant an enormous enrichment. Take, for instance, some persisting German themes which came out in Edith's writing. In Germany the Scandinavian authors were very famous. As a young teenager Edith was deeply fascinated by Sigrid Undset's great historical novel Kristin Lavransdatter, and her own novel *The Golden Hand* was a tribute to this enduring love. The Nibelungen Saga, a vital part of German culture, eventually resulted in *The Twelve Pictures*, to my mind Edith's most extraordinary novel. *The Making of Frederick the Great* was yet another example. However, she embraced English, and later Scottish, literature and culture, above all the English language, with total delight.

Aged fifteen in 1932, Edith never went to an English school,[1] but returned for a few months to Berlin to complete her *Reifezeugnis* (literally, Certificate of Maturity, and roughly equivalent to O-levels). By this time she had written a philosophical treatise, *Über den Wert der Menschen* (On the Worth of Human Beings). She was also writing, still in German, character studies of some of her teachers and early fragments of fiction. Staying with relatives in Düsseldorf she went with her cousin Rita Karpen, a sculpture student, to the famous Düsseldorf Akademie, where she met Rita's artist

friends and encountered the stimulating atmosphere of serious art teaching, and developments in modern art.

Back in England with her Reifezeugnis and enhanced interest in art, Edith briefly attended the Slade and the Central School of Art. Art teaching here in the 1930s was still very academic, with much copying of plaster casts of classical sculptures. The life classes, however, developed her skills in drawing the human figure and her powers of observation. Even in Berlin she had done a lot of portrait drawing and some oils, and whatever her technical deficiencies, she always had an astonishing ability to get a likeness. Once, when she wanted to paint me, I said, 'I don't think I've got a very interesting face.' 'Every face is interesting,' said Edith firmly.

In the Central School's lithography classes she met a group of artists, all much older than she and accomplished draughtsmen, with strong left-wing views and political commitment. This was a period of widespread unemployment, hunger marches, demonstrations and the rise of Fascism abroad (and, indeed, an attempt to establish it in England). These artists, who now included a very young Edith, wanted to use their art in the service of society, socialism and anti-fascism. In 1933 they founded the Artists International Association (AIA). It was an exciting, inspiring, generous time for artists and activists. The leading artists in the group were Cliff Rowe, Alec Koolman, Misha Black, the three James (Boswell, Fitton and Holland), Pearl Binder and Peggy Angus. In 1934 Edith painted a large group portrait in oil of the First Committee of the AIA: Rowe and his wife Ann; Reg Bartlett, signwriter; Alex Koolman and his wife Winnie; Misha Black, designer and commercial artist; and Jay Laurier. Strictly speaking the wives were not committee

[1] Inge, on the other hand, went to Elementary and Grammar schools in London followed by Natural Sciences at Cambridge University. After her studies at Cambridge, she worked in medical and research laboratories for four years, and for many years as a translator.

members, but they helped with the work, as did Edith herself. Rowe and Alex, the pundits, had little regard for Edith's oil paintings but the great thing about this one was the remarkable likenesses. The picture was exhibited in the first AIA exhibition of 1934 at 64 Charlotte Street, but the AIA itself could not house it, and some years after the War it was lost in a house move. Never daunted for long, Edith painted two replacement pictures at the time of the AIA Memorial Exhibition in 1983: one in her style of the 1930s, another as she would do it in 1983. The paintings gave a good general impression and were certainly of historic interest, but they could not reproduce the accurate likenesses done from life.

As well as realistic and satirical drawings, and banners and posters for demonstrations, Edith was doing book jackets

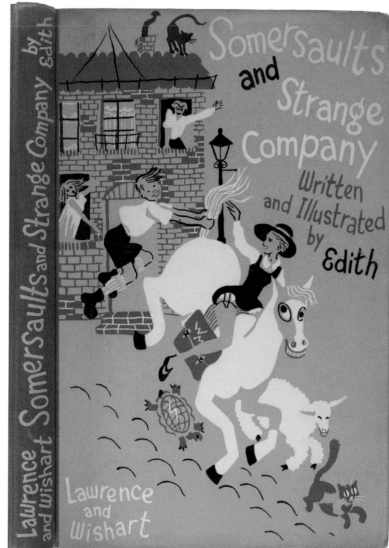

WINNETOU, THE EAGLE-EYED RED INDIAN, AND NTSCHO-TCHEE HIS BEAUTIFUL SISTER

SOMERSAULTS AND

actually blushes every time she has to put it under some document or other in full. Her name is
10

Illustrations from *Somersaults*

and illustrations. It did not pay well, nothing paid well for artists at a time when £3 a week was riches, but: 'For the people I am describing, every damn thing was 'In Short Supply' right through the thirties. You might have ten shillings to get through the week, and sometimes half a crown of that was borrowed … Five Players Weights cost tuppence, three penn'orth of chips was more than you could eat at one sitting, the shilling bagwash furnished a good fortnight's supply of laundry, the Museum was gratis. When the worst came to the worst you were not above drawing with shoe polish on newspaper or cutting a square of lino from the

bathroom/kitchenette in lieu of canvas. Clothes did not matter very much, and anywhere you wanted to go was within walking distance. You could get by.'[2]

Edith was an exceptionally fast reader, and her range was huge. She read not only British and American authors, but, in translation, Russian, French and Scandinavian. The more she read, the more she wanted to write: it began to replace art as her chief interest. English had quickly become the language she spoke and wrote, through her reading, the whole family's addiction to films, and above all her colourful social life of art discussions, political meetings, the satirical pantomimes of the Unity Theatre, parties of every kind and venue, excursions to the country, and working at a variety of jobs in different environments.

An extraordinary fragment survives of her early writing in English. The language is still imperfect, the sentence structure strange. Most people learning to write in a new language would go for imitating the bland clichés of newspapers and light fiction but this is a bold, ambitious experiment – sixty pages plus, typed on what looks like long strands of lining

2 Taken from *The Great Forgery*, Edith Simon, page 6, Cassell 1962.

paper. On the back of each sheet is a rather good drawing – a head, a figure, a limb – just practising. Nothing to do with the subject, a character study of a glamorous villain, a left-wing American student and political adventurer, one Bernard Jacey, and his interaction with penniless artists in drab 1930s' London. Eventually she did full justice to that period in *The Great Forgery*.

Her first book, a preposterous, good-humoured children's adventure story with a strong socialist slant, called *Somersaults and Strange Company*, was published by Lawrence & Wishart in 1937: book jacket and illustrations were done by 'Edith'. The schoolgirl heroine lightly based on her younger sister (me!), travels with her animals – a horse, a lamb, a cat and a tortoise – and friend Robin through a succession of fantasy lands, returning safely at last to home with her loving aunt.

The following year she was commissioned to translate Arthur Koestler's novel *The Gladiators* into English (filmed many years later as *Spartacus* with Kirk Douglas in the title role). It was a sympathetic task. Koestler treats the slaves' revolt against the Roman Republic (73–71 BC) realistically without diminishing its epic quality. Spartacus the Gladiator is both a heroic figure and a real man; the mass discussions are recognisable to anyone who ever attended a political meeting. It is a tragic story, one knows it is bound to end in defeat and death, yet glorious in that it happened at all.

Meanwhile in 1937 Edith had started work on her first novel, *The Chosen* (John Lane, The Bodley Head 1940). Much as she enjoyed working on *The Gladiators*, this was the real thing: a really big project.

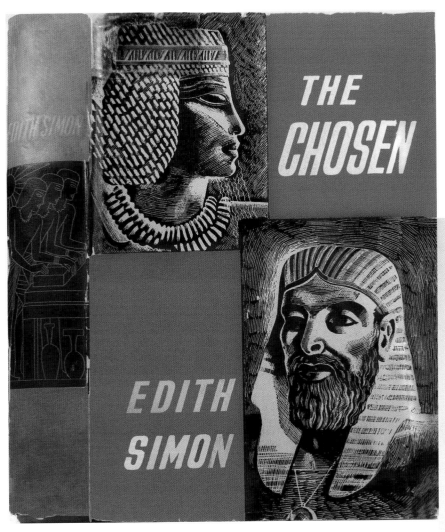

Portrait of Greenwood (publisher of *The Chosen*) 1939
pencil 10 × 8ins

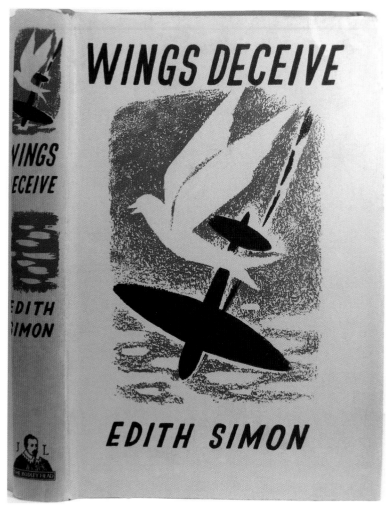

In her time she produced works of every size (including actual miniature pictures), but she was happiest with really large works, the harder to do, the better. She had always been an exciting sister, with her wealth of ideas and her stories about art and novels and friends and parties. It was wonderful to see an exhibition or a film with her. But from now on the excitement moved to a different level.

Edith had long been enthralled by the civilisation of Ancient Egypt, and she planned to write a realistic novel about Moses and the Exodus, leading to a new religion and the defining rise of a people. Reading Thomas Mann's *Joseph and his Brothers*, Josephus's History of the Jews, and numerous books around the subject, she filled notebooks and stray sheets of paper with her notes, all written minutely in red ink. Edith's books went through several versions moving from red ink to typescript, always more than once. To write realistically meant not a reduction of the great story but an expansion; there were always real people acting out their lives against the sweep of history and society. It took her over two years to write *The Chosen*, yet when it was published she was still only twenty-three.

It is a powerful book, with a strong element of humour, present in all her work. An old man, a professional storyteller, comes upon an old woman living alone in the desert. She turns out to be one of the numerous daughters of Pharaoh Rameses II, the princess who found the infant Moses among the bulrushes, became his first wife, shared the wanderings in the desert, and was ultimately cast out for daring to criticise the Prophet turned God. The storyteller knows a good one when he hears it and appropriates her narrative until, aged and dying, he in turn yields place to a young disciple who begins the process of smoothing history into legend.

The novel was received with great enthusiasm by critics, who on the whole agreed that here was a most exciting newcomer. Pamela Hansford Johnson in *Books of the Month* (1940) commented: 'It is an admirable work, adult, finely written, and I have no hesitation in predicting for Miss Simon a brave future.' That was lovely for Edith. Except that, at just this hopeful moment, the Phoney War turned into the Blitz, and virtually the entire edition of *The Chosen* was destroyed in a warehouse fire. It must now be one of the rarest books of the twentieth century. Among its many telling insights and descriptions I remember the total collapse of the Egyptian economy overnight with the exodus of the Hebrew slaves led by Egyptian-educated Moses: end and beginning, and a warning to the great.

Obviously the book made no money, and publishers' advances in those days were tiny. Edith had not expected to make a huge fortune by writing, and she hung onto the day job as a typist-telephonist in a firm of hat makers (30 shillings per week, a living wage even if she had not been still living at home). The Blitz and rationing, getting to work or to visit friends between bomb-craters, blackout and traffic difficulties, stretched everyone's powers of coping. Edith, young, energetic and ingenious, coped as well as anyone. The worst thing for her was the shortage of cigarettes.

Biting the Blue Finger (a quotation from Robert Louis Stevenson's joyous poem *The Vagabond*), Edith's second novel, which came out in 1942, was in its way both a contemporary and a historical novel, dealing with the Phoney War and the Blitz. The dreary details of most people's lives at this time are described with great verve, epitomised by the brilliantly grotesque jumble sale in Sandy's parents' junkyard that starts the book. Sandy, an early specimen of the anti-heroine, was a forerunner of the Angry

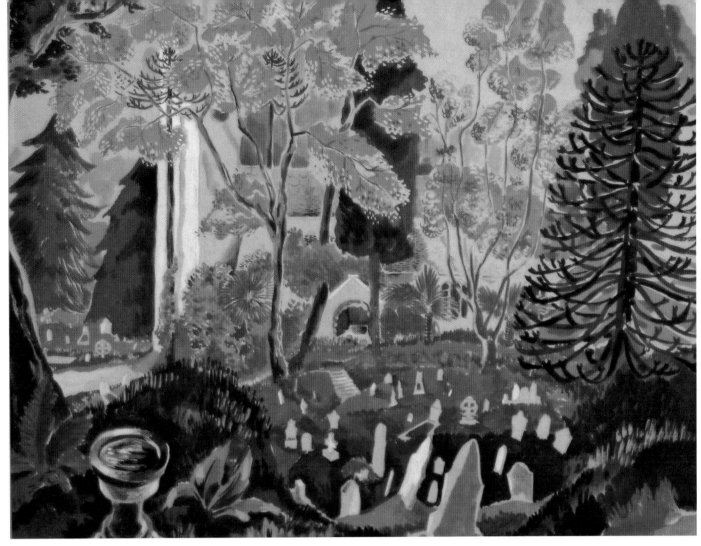

Young Men and the sullen drop-outs of such films as *La Vagabonde*. Hating her drab surroundings and people who will not think, longing for brilliant thoughts and conversations and gracious surroundings, trying to educate herself by reading an outdated *Encyclopaedia Britannica*, she takes out her discontent on everyone else. One feels for her, but would hate to meet her. She runs away to be a tramp, across wintry wartime Britain. All her romantic illusions are relentlessly punctured in turn. It is in effect a picaresque Bildungsroman,[3] with Sandy growing aware of other people and realities at last: the Blitz, and the possibilities of life beyond it. Tom Harrisson, founder in 1937 of the Mass Observation Studies of ordinary people's lives, gave the book a long, perceptive and favourable review in *Tribune*, urging readers to 'make the acquaintance of Sandy'.

Edith's next novel, *Wings Deceive*, begun in 1942, was a veiled tribute to her friend, the author and critic John Mair, who was killed on active service with the RAF. This was Edith at her shortest and sparest, a bitter comment on wasted talents – though we all felt that War to be a just and necessary one. The hero, Laurence, a young writer turned airman, bored and frustrated by service life, transmutes chance circumstances into a menacing thriller, and the woman he picks up, with her evasions and secrecy, into a glamorous spy.

[3] A novel of someone's education and development.

Made ridiculous in his attempt to fight the enemy with individual intelligence, fatally wounded in a raid over Berlin, he becomes a total casualty of war. It is a sad book, but the action, dialogue and characters are often very funny.

Edith's friends had tended to be on the arts side, but in spring 1942 she met Eric Reeve at a party in South London, and Eric was a scientist. He had begun as a mathematician but moved on to zoology, and later genetics. At this time he was working for the government, statistically assessing bomb damage. There was immediate rapport between Edith and Eric. As well as the pleasure of finding interests and values in common, there was the excitement of learning about each other's worlds and experiences.

They were married in August 1942, not having seen much of each other, as Eric was working away from London. Of course, quick marriages were usual in wartime, but Eric was fortunately not being posted abroad immediately (or, in fact, further than Princes Risborough for now). So they were able to have a short but very happy holiday in Cornwall, which also produced one of Edith's most attractive early paintings, the *Churchyard of St Just-in-Roseland*.

When they returned to London Edith and Eric rented a flat at the top of a Victorian house in Hampstead (27/6 a week, and a Tree of Heaven outside the window). Edith completed

Painting for cover of *The House of Strangers*

the final version of Wings Deceive – 'I always seem to have to go wrong first.' – which was published in 1944. The subject matter was not in tune with the public mood, which, though tired of bombs and deprivation, was working up towards D-Day. Undeterred, she continued to write and plan further novels. To me, everything she wrote seemed totally original and different from anyone else's work. But each book was also totally unlike her last, so readers who wanted the same again would often be disappointed.

So, once again for something completely different. *The Other Passion* is an extraordinary political adventure story which also examines the roles of gender and sex. It is set in the first half of the twentieth century. Saskia, the plain and rebellious daughter of Polish aristocrats, joins a small missionary party going out to the Most Westerly Province of China in the early 1900s. Over this desolate mountain region of Central Asia – and its hidden mineral wealth – three empires, China, Japan and Russia, contend and intrigue. As the complex story develops, all the passions – religious, political, sexual and humanitarian – assail the characters. Saskia lives half her life as a woman and the latter half as a man, the General, a successful politician and military commander. Amid the exotic settings and violent events the characters remain human, interesting and true to themselves.

In the autumn of 1947 the Reeves moved to Edinburgh. Eric had joined a team of geneticists working at the University who were housed – partners, families and all – at Mortonhall House. The aim of Professor C H Waddington[4] was minimum domestic responsibility and maximum harmony, common interests and a brilliant social life. In the event, while

the geneticists studied strains of mice and the fruit fly Drosophila in the laboratories, Edith had a unique chance to observe human behaviour in a closed environment.

Togetherness brought out the worst in everybody, including Edith, who had the faults of her virtues, being very quick in judgement, quick to condemn follies and pretensions, to penetrate people's motives churning beneath their words, and very quick to take offence. However, at the same time she could see the entertaining side of everything, and her marvellous long letters describing it all read like a novel. Indeed, they became a novel, planned for the moment as *The House of Dreamers*.

From 1947 Edith was working chiefly on *The Golden Hand*, a novel about the building of a medieval cathedral, inspired by visits to Norwich, Ely and Canterbury. She did an enormous amount of research and planning for this book, which united all her strongest interests and beliefs, above all in the supreme redemptive power of art. It was her main project for the next few years, though she continued to make notes for *The House of Dreamers*. Also, '… I have three paintings clamouring to be done' and a party dress to design and make for a Mortonhall event. Ideas hounded her, and her energy was phenomenal. She always got up early and could work late into the night, with mugs of black coffee and an apple or a piece of sausage (not that this excluded proper meals at other times). Visitors and phone calls were discouraged during the day. This did not always work.

An enforced rest came in September 1949 with a holiday in Switzerland and France, linked to scientific conferences in Berne and Geneva. The climax was a visit to Lascaux and Les Eyzies in the Dordogne, where the recently discovered prehistoric cave paintings were now open to the public. (Soon after this they had to be closed again, because the

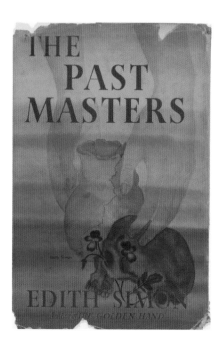

THE PAST MASTERS

EDITH SIMON

4 Buchanan Professor of Genetics in the Animal Breeding & Genetics Research Organisation (ABGRO).

mass of tourists – specifically, their breath – was threatening to destroy within a short time what had lasted for many thousands of years.) This was one of the greatest experiences of Edith's and Eric's lives. Edith wanted to write about it, but though she tried, she found that words literally failed her.

She was hardly back at work in Mortonhall when a far longer rest became necessary. She had always longed for children, but her previous pregnancies had ended in miscarriages. When she became pregnant again the medical advice was to spend the first few months lying still(!) in a bed at Simpson's Maternity Pavilion. She was barely able to write letters, the fountain pen of red ink her only working tool: 'Tuesday, 5.15 a.m. I'll begin this letter like a bad thriller, saying "I'll start writing to you before they shoot me full of dope again …"' The medication was to immobilise her. Nothing else would have done it.

Edith was in Simpson's for several months, and again at the end of her pregnancy. The kindness and comfort she experienced there remained a fond memory for ever after; the only snag, predictably, was not being able to work. However, she did do more planning for *The House of Dreamers*. Of course she had to change everything, as usual, to get the creative juices flowing. The scientists became archaeologists digging up a prehistoric village, characters sprang up, changed their names, appearance, situation, tricks of speech – then to be discarded again. The title changed to *The Past Masters*, though in the USA it was published as *The House of Strangers* (Putnam 1953). She could not do much actual writing between March and June 1950 when she went back to Simpson's for the birth of Antonia, an achievement of medical science, determination and human kindness that caused great happiness.

Babies, however longed-for and delightful, do set their own agenda, and teething is a painful business. There is a hilarious description of Antonia propped up in her cot between her parents typing at adjoining desks, and ceasing to cry as long as the typewriters were rattling away. In the writing, *The Past Masters*, planned as a tragedy of corruption, turned into a dark-ish comedy. It is, perhaps, Edith's wittiest book. Her ear for dialogue, always good, was at its peak, with a sharp relish for the Scottish element. All the little ways in which people do each other down were given full value.

In September 1950 Edith's friend Joan Feisenberger introduced her to a new agent, David Higham. Within two months *The Golden Hand* was accepted both by Putnam in New York and by Cassell in London. On the same day, Edith and Eric heard that their offer for a house in Rosebery Crescent had been accepted. They would at last be able to leave Mortonhall. (One should perhaps point out that some of their fellow Mortonhall inmates remained close friends for life!)

For some people moving house is a traumatic, all-consuming event. For the Reeves it still meant a mass of things to get done, in addition to Antonia, Eric's laboratory research and field trips to the Northern sheep farms (and their writing up), and putting the final polish with cuts and revisions to *The Golden Hand*, and Edith's letters recording all this.

This novel, which appeared in America in 1951 and in the UK in 1952, became a bestseller in both countries. One cannot separate out individual items of its immensely rich appeal. It begins in 1348 – the year of the Black Death – with the finding of a holy relic, allegedly a hand of St Francis, and ends some years after the Peasants' Revolt of 1381 with the inauguration of St Hand's Cathedral in Anglemere, East Anglia. In between lies the whole slow growth of the cathedral, beset by natural disasters, building setbacks, religious feuds and hostile social conditions, but also a tribute to the spiritual motivation, community loyalty and integrity of craftsmanship that wins through. The progress from the 'miraculous' find that is based on a crime yet causes the creation of a masterpiece to the final consummation is deeply satisfying.

Ultimately, it is the people who build the cathedral and it is the people who make the book. The characters of *The*

Golden Hand in all their vivid diversity and their fascinating interaction against 'this rich and glowing panorama of fourteenth-century life'[5] remain in the memory almost as strongly as real-life acquaintances. Years after the glowing reviews of the time, one critic ranked it 'with the finest historical fiction of this century'.

The following year saw the publication of that very different novel *The Past Masters* (Cassell 1953), which found a select but avid readership, though it probably puzzled some admirers of *The Golden Hand*.

In the meantime Simon had been born, in 1952, more easily than Antonia, and a very good-natured baby. Apart from making colourful clothes for the children — and there was a hoped-for third child still to come, Jessica (Jay), born in 1954 — Edith was engaged on her next great project.

While working on *The Past Masters* she had said she would do no more historical novels. The decision was too hasty. She found the Nibelungen Saga irresistibly haunting her imagination. *The Nibelungenlied* is very much part of German cultural heritage, comparable to King Arthur and Camelot in Britain — where the Nibelungs are known mainly through Wagner's Ring Cycle, which has the saga element including the old Norse gods, but from which the human and historical dimensions are missing.

5 Orville Prescott, New York Times

The Twelve Pictures (Putnam 1955 and Cassell 1956), for me the greatest of Edith's novels, is a historical and human retelling of the Saga without loss of its mythic power. The central historical fact is the existence in 'real history' of both Attila the Hun ('Etzel' in the Saga) and Theodoric of Verona ('Dietrich von Bern'). The Huns over-ran a large part of Europe, conquering and devastating as they went. It is extremely unlikely that the Burgundians — as in the Saga — ever got to Hunland, but one can sympathise with the wishful displacement. An amazing feat of imagination, the novel retains the sweep and spectacle of the legend, and the larger-than-life characters. Here are Siegfried, Hagen, Brunhilde, Kriemhild and her brothers the Burgundian kings, but with recognisable emotions and motivation, for all the differences in time and custom. Kriemhild, avenging Siegfried's murder, is ready to destroy both countries. The book can be regarded as a successor to *The Golden Hand,* but it is much darker, more disturbing: almost a counterpoise.

Reviewers were deeply impressed and enthusiastic. 'There are so many virtues to this magnificent retelling of the Nibelungenlied ... that it is difficult to list them all. It is a joy to watch Edith Simon's superior mind at work filling the bare outlines of a familiar epic and embroidering with deft fingers. A new saga emerges, a humanised but still majestic chronicle of outsize emotions, keeping its characters as recognisable archetypes.' (Richard Plant, New York Times, 22 May 1955) 'One of the few genuinely great historical novelists writing today' wrote Joseph Henry Jacks of the *San Francisco Chronicle.* 'Miss Simon's achievement is little short of a miraculous performance ... It is not going too far to call it genius.' The *Illustrated London News* made the book its Novel of the Week: 'This is a feat of learning, but it is indescribably more astonishing as a work of art. For it has the saga-grandeur — as though the Dark Ages became articulate.' The *Times Literary Supplement:* 'The eventful story is packed with real characters. The reader who has finished this long book will look round and blink before he can wrench himself back to the twentieth century.'

Following the success of her historical novels, Edith found herself getting commissions for articles, contributions to miscellanies of historical writing, invitations to participate in symposia, and then to write a history of the Knights Templars. This would be a major task, and sort of accolade. A friend actually said, 'You can't do that, you're a novelist, not

a historian.' Edith, who never willingly turned down a challenge, did not see why, if you did the proper thorough research, history would be the worse for telling a great story in the most interesting way. As she says in her Foreword to that book, *The Piebald Standard* (Putnam and Cassell 1959): 'To most people [The Templars] are barely more than a name today … where once it was a name which rang throughout Europe and the East … As for their story [it] has all the elements of both classical tragedy and the unsolved mystery …' The Order was founded in the twelfth century to protect pilgrims to the Holy Land. Its banner was part white, to symbolise Christian purity, and part black, for fierceness in battle. The book is totally absorbing; it was widely appreciated and translated into several languages. The *Times Literary Supplement* wrote: 'Readers of her historical novels will not be surprised she has made the most of her theme, doing full justice, for example, to the rise of the Order, to the personalities of its Grand Masters, and to its feats of arms in the Holy Land. Even more notable is her success in placing the story of the Temple within its proper historical setting.'

The Sable Coat (Cassell 1958) was planned and largely written before the Templars commission came in. This was a contemporary novel again, Edith's second with an Edinburgh background. It is an uncomfortable book, but the 1950s were an uncomfortable time, of social readjustment, coping with post-War changes, striving for ideological justice and psychological self-denial. Marie, the chief character, is never at ease – with herself, her marriage or her family, least of all with her domestic help Kirstie, who, needy and devoted, turns into an incubus, echoing the family's long involvement with their German nurse Fricka. At times it almost becomes a horror story. But, as ever, there is brilliant observation of detail, accurate dialogue and allusive wit.

In their way all Edith's modern novels are also historical novels, and none more so than *The Great Forgery* (Cassell 1962). It utilises her experience of artists and bohemian life in 1930s' and 1940s' London. From the flawlessly squalid studio to the democracy-of-true-art litho class, the author has been there and relished it all: the gossip, the ideologies, the contempt for those who have not got 'it' and the grudging respect for those who have The Gift. Not that Edith's respect, when she felt it, was ever grudging: she had full admiration for the great masters, and a generous fellow-feeling for those who as yet were merely trying.

Matthew Gorer, the protagonist, is an anti-hero on a truly heroic scale. He has all the gifts and capacity for work and all the requisite bloody-mindedness, but he can never achieve consummation. He also has all the best lines in a novel crammed with splendid repartee. Little Cassy, his femme fatale, exquisite with the exotic beauty of her mixed-race origin, falls truly in love with this monster of discontented talent, and the course does not run smoothly. There is a host of wonderfully depicted minor characters. As for the central forgery itself, the martyrdom of endless painstaking labour is so realistically recreated – no-one but a practising artist could have done it – that the reader suffers in sympathy. 'This is a most brilliant, witty and civilised tour de force,' wrote Peter Green in the *Daily Telegraph*, seeing Gorer as a Falstaffian hero and, like Falstaff, ultimately a tragic figure.

One revives an old love at one's peril. There were several excellent books still to come, but the seduction of art was to prove irresistible to Edith.

Her next book was another straight history, a biography of Frederick the Great. This was to have been in two volumes, but in the end Edith was glad to do only the first: *The Making of Frederick the Great* (Cassell 1963). Many books have been written about Frederick II of Prussia (Germanophile Carlyle devoted ten volumes to him), but Edith had two strong new threads to contribute, plus her experience as a novelist: first, there was her German schooling, which presented Frederick as the great national hero to cherish against the humiliation of World War I; and, second, the particular post-Freudian interest of Frederick's miserable childhood and his relationship with his monstrous father Frederick William. Frederick, drawn to the arts and civilised values, was abused and brutalised by a father convinced that his hidebound militarism was the only true course for his country and his luckless family. Yet when Frederick William died, Frederick was inconsolable and eventually turned into a more intelligent and successful version of his father, planting little Prussia and its army squarely on the European map. His personal life never recovered but alongside his military triumphs he wrote poetry and plays, composed and performed music (the flute was his instrument), and held his own with the intellectuals of the age, such as Voltaire. 'Admitted into the ranks of poets and thinkers by the foremost living authority in the field, Frederick was in the pleasant position of being able to feel superior to his intellectual friends because they knew nothing of war, and to his generals because they knew nothing about art. Where other men of action could but hope for the best at the hands of the historian, he could put his own pen forward.'[6] (cf. Winston Churchill, 'History will be kind to me for I intend to write it.')

A commission came from Weidenfeld & Nicholson for a book on *Manners and Morals in the Age of Chivalry* for their Pageant of History series. Edith produced a synopsis, but fundamentally she was out of sympathy with supplying a light version of what she had done seriously. Instead she suggested doing a short book on the Early Christians for the series. Weidenfeld accepted the suggestion, and this book became *The Saints*, to everyone's advantage.

Meanwhile she wrote two plays, *The Inimitable* about Dickens, and *Love Me, Scum* about Frederick II and his father. A theatre agent was enthusiastic about them and tried to place them. There were near misses with Laurence Olivier

and the BBC, but although Edith spent time she had not got revising them to order, and although the extant versions are full of excellent things and meaty acting parts, they have never been performed. However, the Frederick book was very successful, in the UK, in the USA and, in translation, in Germany, where it is still a valued source book.

Edith and the family had moved again, to a larger house in Lansdowne Crescent. Diagonally opposite, in Grosvenor Crescent, was the Ballet School of Marjory Middleton, where Jay, the youngest Reeve, later became a pupil, and which teemed with tempting subjects for an artist interested in the human figure.

Edith's American publishers, Doubleday, suggested she might do a book on Joan of Arc, for their Crossroads of World History series. Edith felt that enough had been written about Joan of Arc, nor could she see her standing at the Crossroads of World History. The figure that fascinated her in this context was Martin Luther. She had been deeply dissatisfied by John Osborne's play about him – 'No suggestion how or why the spiritual torments of this man had transformed Western thought …' – and suggested a book about Luther to Doubleday. Our mother commented: 'If they want Joan of Arc, I can't see that they'll be satisfied with Luther.' Edith must have put it very persuasively, however, as Doubleday showed enthusiasm for the idea, and she embarked on yet another huge project.

Time-Life had also commissioned Edith to do a short illustrated book on the Reformation. She thought this would fit in well and not be too difficult, especially if Time-Life were going to compile the illustrations. The idea was for an intellectually superior coffee-table book.

Apart from *Luther Alive*, which Edith found of absorbing interest, though extremely hard work, there were now constant hints that she would rather be making pictures. 'Four pictures in oils (instead of writing!) … everything else going to rack and ruin …' 'Mind you, I really think I am getting somewhere with the painting just now. Really advancing – though, as with my writing, doomed to totally different experiment every time.' 'If … you are interested in art, there is quite an accumulation, not to say exhibition, of 2 new lines – enough for me to be seriously beginning to think in terms of a one-man show (some time).' The two new lines were

the continuous-line drawings – possibly inspired by the improbably fluid movements of the young dancers at the ballet school – and the earliest papercuts, also of dancers.

The great thing about *The Saints* (the book about the Early Christians for the Pageant of History series) was that it must be limited to 25,000 words. This bore out Edith's belief in the creative stimulus of limitations. Though an atheist herself, she was always fascinated by religion, its manifestations and influence on other aspects of civilisation. By limiting herself to the earliest Christians Edith illuminated one of the most interesting and least familiar developments in Christianity. *The Saints* (Weidenfeld & Nicolson 1968) is a fine, satisfying work; concise and controlled, packed with ideas, and beautifully illustrated.

The Time-Life commission for *The Reformation* (1966) was a less happy story. Time-Life did not like what Edith produced, thinking it too difficult for their readership. They suggested that their editors, as well as being responsible for the illustrations, should simplify the text to make it more attractive to the general reader. The result was a good-looking coffee table book for the Great Ages of Man series, but the text had been edited out of its life and bore 'so distant a resemblance to my MS as only a mother's eye could discern.' But then, who actually reads a coffee-table book?

All the more incentive to do justice to Luther and the Reformation now. *Luther Alive* portrays a living man, with faults and inconsistencies, but essentially the monk who with heroic courage and powerful intellect – and of course, he hoped, the support of God – stood alone against the power of the Church and the Holy Roman Emperor Charles V. Luther's aim was to reform the Church from within, purging it of the abuses that threatened its integrity with commercial bargaining. Not long before, that Church had burnt Johann Hus, and more recently Savonarola, for such 'heresy'. They certainly burnt Luther's works in public. His triumphant survival of his own doubts and torments, confrontations with all the religious and temporal authorities, his life-saving abduction by supporters and long concealment in the remote Thuringian stronghold of the Wartburg, where he translated the Bible into German, epitomise heroic struggle and its reward, later including the happy marriage and family life with the runaway nun Katharina. 'A celibate monk could not have led the Reformation, as its father figure.' (*Luther Alive*

p. 354) It is a wonderful character study, and an excellent rendering of the complex sixteenth-century context with its turmoil of events and changes and vivid characters. Reviewers praised the book's liveliness, insight and brilliance, and its full attention to other great figures of the period. 'Historical writing at its best,' said one. 'The most informative and scholarly volume ever published about Martin Luther,' said another. 'The story of his life has been told many times, but never better,' yet another.

The Anglo-Saxon Manner, Edith's last book, was originally commissioned by Doubleday, but was eventually published in the UK only by Cassell in 1972. It is an undervalued book, which presents many interesting and original ideas. However, the Anglo-Saxon contribution to civilisation was really too big and vague a subject, nor was it the straight history which Edith most enjoyed. She did enjoy writing the article on Frederick the Great for the next edition of the *Encyclopaedia Britannica*, and various cultural articles for glossy magazines.

However, the most exciting developments were now on the art scene. She had so many new ideas that it was hard to keep up. Her papercuts became more complicated, with many coloured layers in place of black and white or white-on-white, giving the effect of painting as well as sculpture. The continuous-line drawings diversified into three-dimensional rope sculpture. The Crown of Thorns in St Mary's Cathedral, Edinburgh, is the sole example to hand, but people still living can testify to the agonies of resinating recalcitrant rope to make it self-supporting …

The mobile sculptures which formed the bulk of Edith's output and her exhibitions for the next few years were embodiments of her abiding interest in movement. These beautifully painted figures were made of jointed stuffed sheeting, their essence being that they were *mobile* and could be infinitely rearranged (unlike, say, Oldenburg's famous soft typewriter, which merely sits). In a letter of 1970 Edith asked Inge for more sheets: '*The Trojan Horse* will take at least 2.' They were decorative and ingenious. Two that I particularly remember were a brooding Rembrandt and a fetching little Mozart (the infant prodigy, displayed sitting at a piano). Then there were see-through pictures, consisting of superimposed translucent layers, sculptures in various experimental media (stained wood, ciment fondue, vacuum-formed Perspex, cast polyester resin, cold cast bronze,

copper, aluminium, worked metal sheet, cast and carved plaster, painted glass – over a period of years) and trompe l'oeil painted furniture, such as the pair of male and female armchairs, also murals in paint and wood veneer for various people.

It was the ongoing sense of exploration that made Edith's exhibitions so exciting. Each time – and there were over thirty years of her annual Festival exhibition – it was like walking into a still evolving world. But it also meant immense difficulties with the setting up. Some problems were creative, such as finding effective juxtapositions and themes. Problems with other people or conditions of the venue were less tractable. Edith never received support from any public body, so for finance, publicity, recruiting and organising helpers, it was up to her own resources and ingenuity. Those who did help found the adventure exhilarating and addictive.

Edith had sent in work to mixed shows, but her first one-man show was at the small private Galerie Balans in a basement in Amsterdam in 1971 when she showed mainly mobile sculptures and continuous-line drawings. (This show went on to a gallery in Tilbourg.) To transport thirty-two vulnerable works of art across the North Sea in a hired van (Eric had never driven one before) was somewhat being thrown in at the deep end. The following year at the Gardner Centre, University of Sussex, Edith showed works in seven categories. By the time of her 1973 exhibition at the Talbot Rice Gallery in Edinburgh, diversity and development were in full flow.

Many years and exhibitions later, Edith commented grimly that 'I could write a book about putting on exhibitions …', adding the non-writer's customary corollary of '… if I had the time!' Yet, however incredibly busy Edith was, she was always aware of other people; she had time to listen to the problems of friends and give practical help or advice, or both. Her professional advice to the creative young was expert, tough and fruitful. Many will remember the terrific stimulus of her personality, her conversation and – *mea culpa*, ruefully – her example.

On a family holiday in 1995 Edith contracted a respiratory infection which very nearly killed her. Back in Edinburgh she gradually recovered, but the underlying condition of emphysema was now revealed and irreversible. She had to be on oxygen for the rest of her life. Not that this stopped the creation of new works, or the sitting-in at her own exhibitions, or social life, appearing at parties and exhibition openings in her trademark colourful clothes and spectacular jewellery, or even a modicum of travel. Her husband and children were an enormous help to her all along, but particularly in those last few years.

Two months before her death she said to me: 'I've had all I ever wanted to have, I've done all I ever wanted to do, and I've had the most wonderful family.'

You could hardly say fairer than that. She did have it all. Moderation be damned.

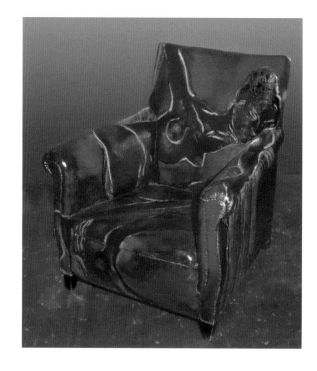

Nude Chair 1973
painted chair 48 × 30 × 36ins

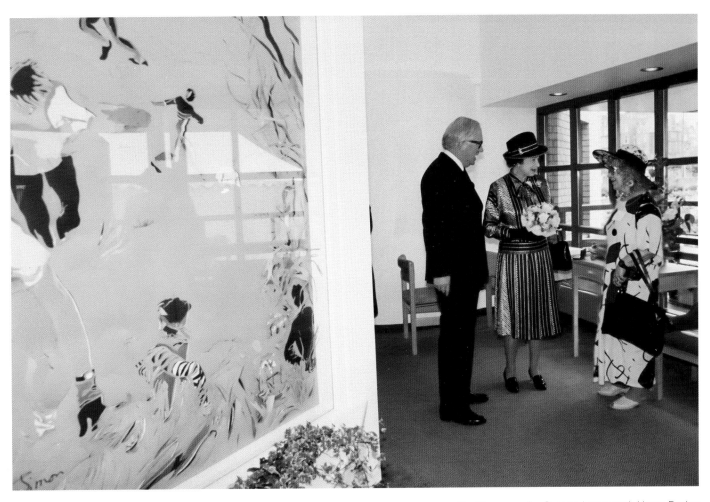

The Queen unveiling Runners, Lammermuir House, Dunbar
1986 nine colour layers and sculpture 180 x 72ins

Water babies 1976
bath paint 72 x 72 x 36ins

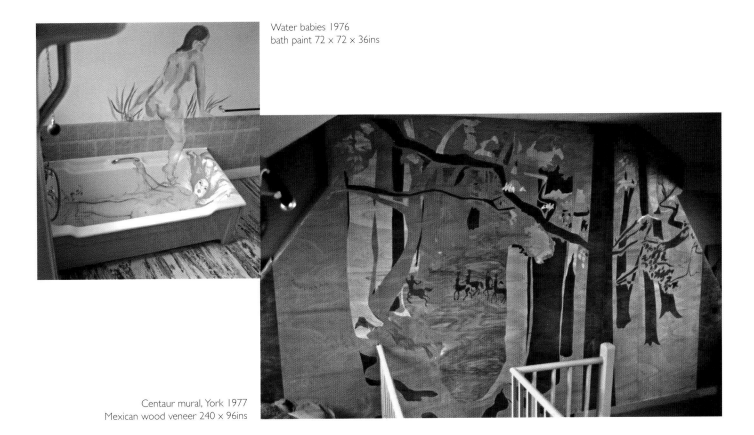

Centaur mural, York 1977
Mexican wood veneer 240 x 96ins

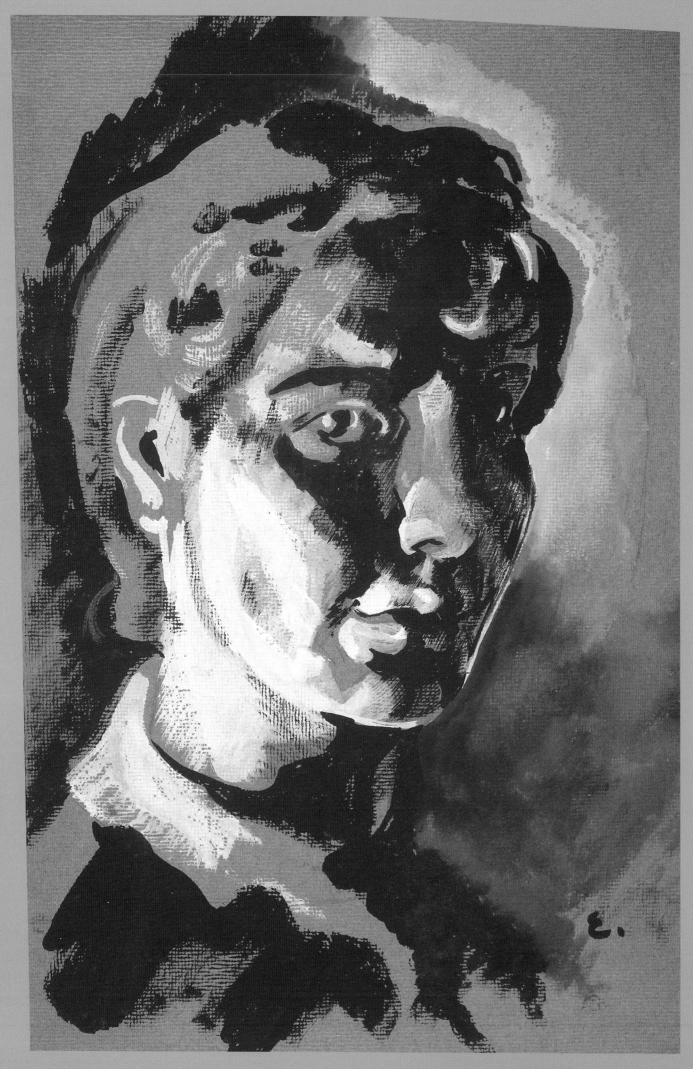

Self Portrait 1930 bodycolour 11 x 8ins

EYE WITNESS
by edith simon

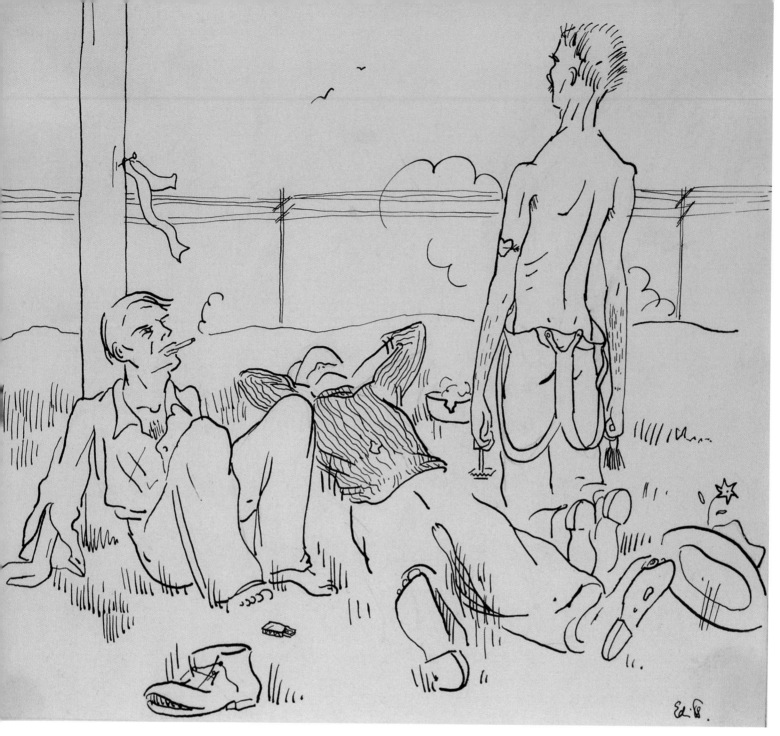

Camping Holiday 1934 ink 8 × 8ins

'Portraits 1 shilling, caricatures 6 pence' 1933–4

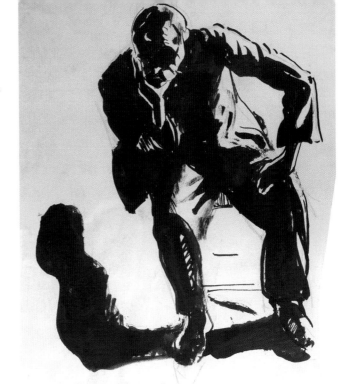

Thinker 1934 ink wash 9 × 8ins

EYE WITNESS
by edith simon

I joined the AI at the very meeting which decided on the name of Artists International, and which formed the first Committee. The committee consisted of everybody present except me, who knew nothing about politics or procedures. But I'd just begun to teach myself to use a typewriter. Nobody else could; so then and there I became the AI typist.

Cliff Rowe and Misha Black were the prime movers, together with Pearl Binder, who had also been to Russia.

The titular secretary was Ann Meblin, Cliff Rowe's wife – not herself an artist. They had come together in Russia and had arrived from Moscow only a week or two before: living in a sort of outhouse in Old Gloucester Street, Bloomsbury, which belonged to a friend. Other friends were helping them with clothes and pots and pans and groceries – bacon and eggs, said Rowe, was the one thing he'd missed in Russia, where everything was in equally short supply, with the exception of enthusiasm.

He had lived there for 18 months, that means since 1931, when the pioneering atmosphere of the idealistic 20s still flourished in Russia, where foreign visitors were welcomed with open arms and allowed to roam free.

It is important to understand the heady impact abroad of the young Russian Revolution as a constructive liberating force – much like what happened at the beginning of the French Revolution. Also, the Soviet Union then was all geared to internationalism. It stood for world socialism, without any nationalistic pretensions.

Well; Ann not longer after returned to her native America and Rowe became the secretary. He and Misha Black remained the leading spirits for the next few years.

I continued to do the typing – minutes, correspondence, manifestos and leaflets, articles, stencils, the lot – so was closely involved in everything, from the shaping of aims and policy to practical day-to-day activities.

I don't know what the left-wing movement had done without us! We painted banners, often through the night, and monumental heads of Marx and Lenin for demos in which we also marched. We designed and printed posters, made scenery for Unity Theatre. We made murals. We drew portraits, one shilling, and caricatures, sixpence, at Daily Worker bazaars, in relays, by the hour. A liberal education in every respect.

I remember some painting expeditions and informal life classes, also a camping holiday by a lonely beach in Essex: about a dozen adults, two babies, and fluctuating visitors.[1] We had a marquee to work in and a gramophone to dance to, and ping pong: Misha was altogether a great organiser and he knew a sympathetic lorry driver. You don't imagine any of us had cars …

In the open air or out of it, discussion never ceased, about Marxism and culture, form and content, art and propaganda; about techniques of painting and the use of new materials for sculpture; about the capitalist crisis. People talked and argued as they worked together, amid endless cups of tea and yards of banner linen and gallons of red paint and printing ink. There wasn't any special workshop – one used the floors and walls of Rowe's and Misha's flats. In fact Misha's girlfriend left him, saying she could no longer bear the blood of Lenin running down the wall. (It's all right: they got married in the end.)

1 Edith Tudor Hart, John Heartfield, Francis Klingender among them.

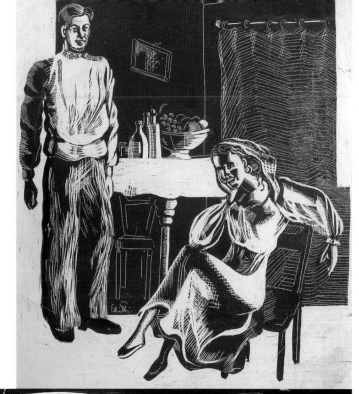

There was constant need of banners – for hunger marches, anti-war and anti-fascist protests, to express indignation at diverse costly royal pageantry, and for standard rallies like May Day, with redoubled output when the Spanish Civil War broke out, which united all the causes of the Left and all its factions, most acutely.

You don't think one got paid. Much of the time we were lucky to get the money for materials out of the various organisations. The gibe then often levelled at such bodies, that they were subsidised by Moscow gold, drew wistful smiles.

Book-keeping was cursory. Whoever had cash handy, forked it out. Better-off friends were coaxed or blackmailed to help finance exhibitions. Now and then donations came in kind, for the Bulletin and such like. Duplicating and distribution were by voluntary labour too – the silver lining of Unemployment!

Familiar as all this may sound, it isn't true that the more things change, the more they are the same. The crucial difference between then and now was twofold: there was no social security, but on the other hand there was strong, positive, confident hope.

Most artists were poorer than anybody young today can easily understand, with not even the dole to fall back on. But we knew that a millennium was attainable. Progress had not yet become a bad word, history was still seen in an ascending line.

For fascism was as yet only getting into its stride – a vicious reflex of capitalism in its death throes and thus kind of a

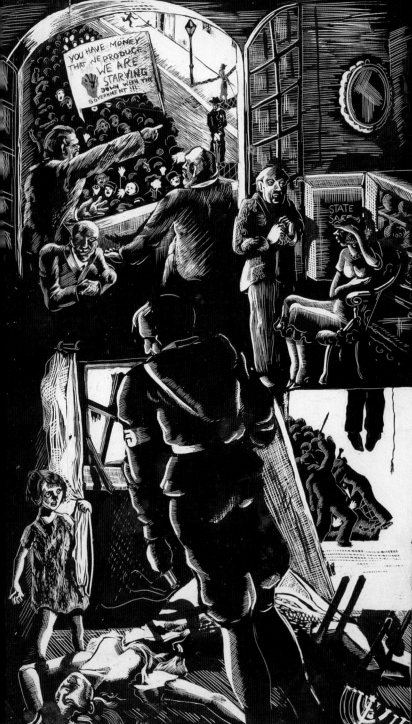

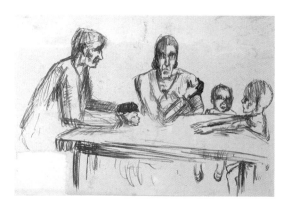

heartening symptom really: we would stop it. As for the threat of war, the 1914–18 carnage was still so vivid in the public consciousness that given enough reasoned propaganda the old conspiracy of the capitalist armaments ring should be foiled.

The word totalitarian, even had it been current which it wasn't, would not have applied to Soviet Russia, where it seemed social justice reigned, hand in hand with the maximum advancement of human potential and resources.

The contrary implications of Stalinist policy had not begun to filter through. Indeed it wasn't till after the Kirov assassination in 1934 that the Terror was systematically developed.

There was no unemployment in the Soviet Union, rather the reverse. It was the only country where foreigners of any trade didn't need work permits. And art was respected as a vital organic part of society so that artists were in huge demand.

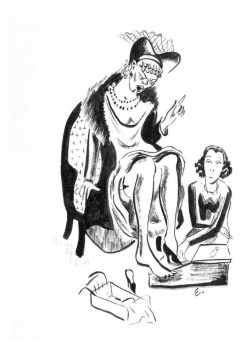

Shoeshop 1930s ink 8 × 6ins

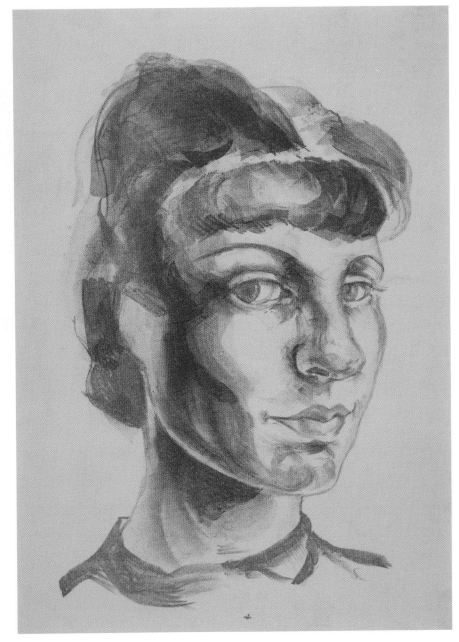

Self Portrait 1934 lithograph 14 × 12ins

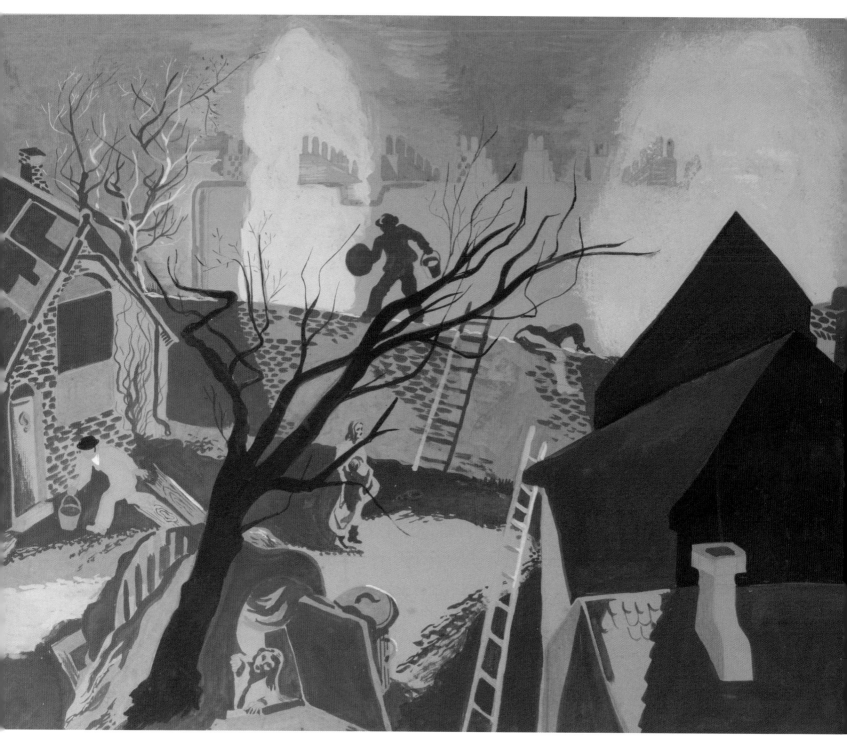

Firebombs Camden Studios 1942 gouache 16 x 24ins

The Underground 1930s pen and wash 4 x 9ins

THE POMPOUS ROYAL ACADEMY
IS FORESTALLED FOR ONCE

PAINTED ON BROWN PAPER, this picture of "Sunday morning," by Miss Edith Simon, is at the
London exhibition of artists "united for peace, democracy and cultural development."

Not so in Britain. A contemporary survey tells us that the great majority of artists was unemployed. Lucky were those that found teaching posts or managed to live hand to mouth on free-lance piecework like book covers and illustrations, not to mention temporary jobs making drawings of jewellery at 30 shillings for a 56-hour week or painting lampshades or colouring cartoon films for a weekly wage of 25 shillings. I had done both the latter, and being way under age received 10 shillings and sixpence. I can tell you that was next to nothing then too. But the alternative was nothing at all.

People painted barber poles, tried to sell vacuum cleaners, or did copytyping (me again) at the rate of threepence per 1000 words, top and 2 carbons …

At least this state of affairs helped to erode the old internecine snobberies as between easel painting and commercial art.

Getting on with one's work betweenwhiles wasn't easy either, since materials cost money. I recall paintings done with shoe polish on newspaper – good discipline in its way no doubt but poor practice in the long run. That was where the celebrated lithography class which Jim Fitton ran at the Central School was a great stand-by besides serving us as a crypto discussion club: for 10/6 a term you got the use of materials and equipment thrown in. In my case, I gratefully remember, the then principal even waived the fee.

Private patronage, never ample, had dried up with the Depression. State patronage there was none. Commercial artists with 'real' jobs were considered well-off on £3 and £6 a week and were jolly well expected to share their cigarettes with the rest of us and stand us the odd meal. At that, the quality of the work required of them was most often abysmal and thus a terrible grind. But for the great and good Shell Oil company and London Passenger Transport Board, enlightened sponsors who offered a magnificent £100 for a poster and encouraged enterprising design, there prevailed an all-time low, by and large.

A lot of indigent artists lived around the back waters of Soho and especially Bloomsbury with its Georgian architecture in sub-standard slum condition – since razed by bombs and replaced with office blocks, alas. During the war

Camden Town became popular. At one time Peri, Priscilla Thorneycroft, Carel Weight, Cliff Rowe, Alex Koolman, me, and a non-engaged sculptor, one-time winner of the Prix de Rome who modelled for the Royal Mint, occupied a cosy ramshackle enclave called Camden Studios, with one small Anderson shelter planted in the middle of the yard. It's the scene of my little picture of the Blitz. – Hampstead was for the more affluent. – If furniture consisted largely of packing cases, that made it easier to flit when the rent fell too far into arrears.

In James Fitton's words, 'Everyone was to the left then. What else was there?'

Can you imagine the upsurge of energy and will from the news that art could actually help to revolutionise society; that art and the values it embodies are a fundamental part of society; that the thorough integration of art into everyday life must enhance the quality of both and improve the artist's livelihood and status. Clearly artists formed the natural vanguard in the fight for peace, freedom and full employment. The AI among its other functions would become the artists' trade union.

The vested trade unions wouldn't have anything to do with us, though. The Left spectrum had many shades, ranging from the Marxist intellectuals to the plain humanitarian sympathisers. The Labour Party of that time was considerably to the right of centre; it saw red everywhere, out of all proportion to the then quite neglible numbers and influence of the communists.

While certainly the AI had derived much of its impetus and strategy from Marxist inspiration, it maintained the broadest possible platform. It had to, so as to allow the broadest affiliations. Otherwise there was the frankly communist Hogarth Group. The only CP member on the AI committee was Cliff Rowe – and the Party directed him to shave off his

William Treton, carpenter 1930s
gouache 15 × 12ins

minimal beard, because the workers wouldn't like it. That was in England, not in Russia – a sacrifice to the Popular Front. To the same end, the Artists International became the Artists International Association. The revolutionist noun turned into an innocuous adjective.

Actual links with artists' groups abroad were mostly by way of mutual contributions to exhibitions. Except for the concrete help extended to refugees from Nazi Germany and later Spain and Czechoslovakia – but that's in a different category of action.

There was never any question of the AIA as a stylistic movement. True, the idea of Socialist Realism or Proletarian Art, as formulated by the Soviet Writers' Congress of 1934, did spark off a notable stimulus. Remember nobody knew then what it was to lead to, in the line of heroic kitsch, nor in the way of wholesale anti-modernism. Logical for us to assume that it had to do with subject matter primarily, with the proviso that as regards treatment, representation should be recognisable by the proletariat.

We didn't in fact make much headway with the proletariat, as witness the failure of the Everyman Prints scheme. Still the innate virtue and wisdom of the working class remained axiomatic. We made much of being workers too and sought to play down any bourgeois antecedents of our own – those that were so burdened. We believed that salvation lay in levelling down and that environment not heredity determined intelligence and aptitudes entirely. Individualists in the way we lived, we condemned individualism as a reactionary heresy. But nobody had the slightest wish to control other people's manner of working. Realism was the chief objective – but realism is a protean term. After all, the

AIA supported the surrealists and didn't turn down Barbara Hepworth or Picasso. The very diversity of works brought together for a common purpose in the AIA's big partisan exhibition was what made them so effective.

I'd say that the only AIA activists who really made the grade under the head of political art were the 3 Jameses (Boswell, Fitton, Holland), Cliff Rowe, and Peri. I was amazed when I first saw The Story of the AIA Exhibition in Oxford last year, how much livelier and more original than most people's I now found Peri's work. I'm sorry to say that many of us didn't think much of it at the time. Maybe his slightly difficult personality had something to do with it –? A chastening thought – but then, who can claim absolute judgment? Lest we forget – there are always personality clashes and power struggles in even the most high-minded groups.

Having got this off my chest and made my apologies to Peri's shade, I find this a good moment to pause. I've tried to evoke the feel of those early days, rather than recite a blow-by-blow synopsis. The exhibition does give a pretty comprehensive outline of the story, filled in by Lynda Morris and Robert Radford in their book which is a model of research, analysis and presentation. Read it!

I'm merely concerned with the beginning and the end – the periods of birth and growth and of decline.

You will have gathered that the political clause was erased from the AIA Constitution in 1953. It went as follows: 'To take part in political activity, to organise or collaborate in any meeting or demonstration in sympathy with the aims of the Association where action seems desirable or justifiable.' After this had been expunged, the AIA turned out to be effectively dead, though it wouldn't finally lie down till 1971. With the clause intact, it had lasted longer than any other artists' group I know of.

So what do we make of that?

Once again, Soviet Russia was the key. From being a land of radiant promise, Russia had changed into a repressive menace in the eyes of her former disciples. The fear of being tainted by association was as strong as the fear of Russian aggressiveness itself. Dissociation was the answer. Well and good – but was it necessary to abnegate political

commitment altogether? Talk of throwing out the baby with the bathwater. Political commitment had been the whole essence of the AIA, its raison d'être. There is a quotation, He that saveth his life shall lose it. Cutting loose doesn't have to entail cutting your throat, does it.

To be fair, wisdom is cheap after the event, of course. I wasn't in on any of that, either way. Though I never left the AIA, I'd just faded away, well before 1953. Partly because I had turned to writing, came to live in Edinburgh, and didn't go back to practising art until the 70s. But partly, too, because for me the old sense of urgency, of being in the thick of things, had passed, as with the wider expansion of the AIA it had acquired a sort of Establishment look of its own. It happens ... 'Pity they have to grow up,' as the saying goes.

If in the Exhibition one saw few if any great works, it goes to illustrate the perennial dilemma as between creation and promotion. Time and energy are elastic – but not infinitely so. There comes a point where the artist has to choose which to give most of himself to – the work as such or the

endeavour to build optimal conditions for it. We should perhaps salute those AIA pioneers whose names and works have failed to leave a mark, as willing martyrs to the artist's cause as large. We should not be here, now, [2] but for their dedicated effort.

How much of the art of any given age is "great"? Considering the vast increase of populations and their life span, the percentage cannot but diminish sharply as the numbers grow to whom art becomes an accessible occupation. Does that matter?

Since the beginning of recorded art, from Lascaux to Guernica, the majority of great works has sprung from ideological sources and has striven to improve the quality of life – implicitly, for you don't have to spell everything out. I believe the moral of this story is that the totally uncommitted practitioners of art abdicate their right and their duty of social participation and true creativity. At best that's self-castration. It can seriously damage your health.

2 Footnote: this talk was given at the Arts Council's Fruitmarket Gallery in Edinburgh.

Domestic Bliss 1930s
pen and gouache 12 x 10ins

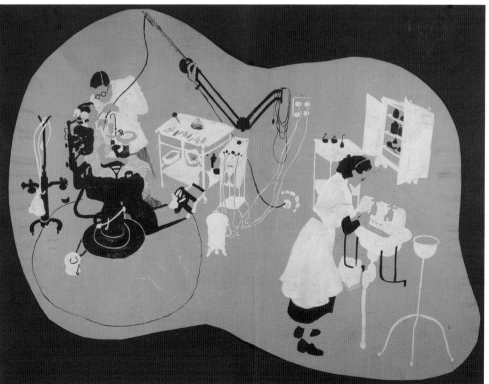

Dentist 1930s
poster colour 18 x 10ins

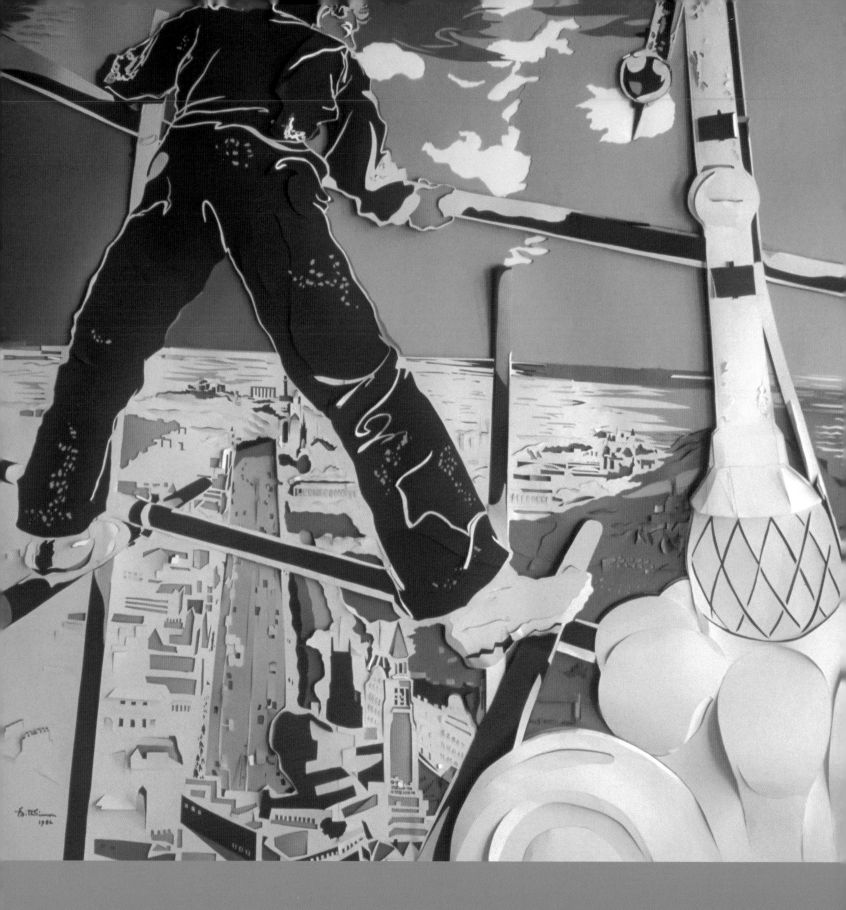

300 feet above Edinburgh 1986 five colours 48 x 48ins

MY EDINBURGH
by edith simon

MY EDINBURGH

by edith simon

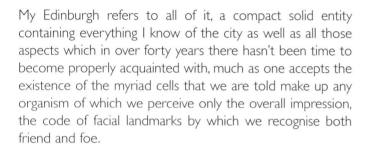

My Edinburgh refers to all of it, a compact solid entity containing everything I know of the city as well as all those aspects which in over forty years there hasn't been time to become properly acquainted with, much as one accepts the existence of the myriad cells that we are told make up any organism of which we perceive only the overall impression, the code of facial landmarks by which we recognise both friend and foe.

Here it is definitely a case of friend. Edinburgh has long become my element; I wouldn't now live anywhere else. Whether it likes me too, or is indeed aware of me, is immaterial to the feeling. Reciprocity is preferable but not decisive.

In what other city do you emerge from the railway track of your arrival straight into one of the most attractive views in the world? (Air terminals don't count; they're all more or less the same.) At once splendid and welcoming, romantic and commercial: the latter factor, in an age when freedom and democracy appear to be equated with shopping, can't be all bad even if aesthetically deplorable.

Where else do you find, cheek by jowl, a royal palace, an ecclesiastical ruin, a laundry works, a brewery, and an extinct volcano? The same diversity is echoed all over the place. You turn a corner by a classical façade and are confronted with a mess of cottages or a quasi-slum. The city's social life could well be symbolised by the overlapping circles of the Olympic Games: I've always thought so, not merely in an Olympic year. It might also be likened to the interweaving ebb and flow of Scottish country dancing.

There are the traditional enclaves of law, medicine, university, administration, banking, manufacture, and many tougher trades – though admittedly all at present eroded and debilitated by hectic cutbacks – which have opened up sufficiently to allow degrees of linkage, not least under the influence of the Festival. Where once were only coffee mornings or pub crawls there are now champagne openings galore and on the other hand bingo. Though much of this carries on all year round, art galleries owe their astonishing proliferation largely to the Festival, as does experimental theatre, epitomised by the Traverse whose seed has spread throughout the world.

A general atmosphere also lingers, of a certain genial flexibility, of leniency, so to speak, towards new experiences, of some blurring of class distinctions – for all that not a few natives continue to be hostile to those rich, basic three weeks when everything hums with animation and every kennel offers an imaginative show. Yes, one still meets inhabitants who proudly boast that they always go away for the duration. But perhaps that is to avoid the road works which over that period make for holes and hold-ups all over Edinburgh.

Well – without friction no sort of life comes into being; without contrast there's only a universal blank. I do enjoy the contrasts, and their diversity, too. The worn stone steps set between bleak walls but leading to elegant apartments in what surely remains the happiest style of domestic building ever devised by man (I note that most of our local modern architects actually reside in the New Town if they can). The austere grandeur of St Giles; mummery in the Assembly Hall, with Knox below apparently unperturbed by the offence. Those unseemly blots, the St James Centre and tourist traps infesting the Royal Mile: the scree of cheese-box rooftops saddening the eye from the crest above Corstorphine – but isn't a mole on a damask cheek (real or artificial) called a beauty patch? Perhaps unblemished perfection would not be so habitable.

I've often wondered whether the Parthenon on the Acropolis of Athens would have inspired the same awe and sensuous satisfaction when it was new and whole. I fancy I can hear pundit murmurs of "Wedding Cake!" just as you still get persons who deplore that so much of Auld Reekie's blackness has been scrubbed away. As for our very own Parthenon on Calton Hill how quirkily fitting that it should have been left unfinished rather than depleted by time.

There are unplanned effects which startle you with a sense of the miraculous: when on a clear day the Firth of Forth stands at the bottom of the street like an acrobat balancing foreshore and hinterland of Fife, equally upright, on its shoulders. That the hills all round pop up in unexpected places is a pleasant but not so other-worldly feature. The huge and ever-changing skies above add an extraordinary bonus.

Edinburgh is a metropolis, full of surprises but spatially manageable. If you had to, you could reach every part of it on foot. It is a metropolis that remains human. Your neighbours are not so close that you can peer into each other's saucepans, nor so remote as to become like ants with whom there's no immediate bond of fellowship, as happens in many great cities.

And talking of the weather in the streets – while I love the sun and make a beeline for it on holiday – I don't essentially mind the prevailing unpredictability of the climate. Somehow it helps to keep you on your toes: it maintains readiness for adventure. True, there can be too much of a good thing. Some Festivals ago when it did nothing but rain, a visitor sheltering among the columns of the RSA was heard to say: "Why don't they just cut the moorings and let the whole place sink!" Now that's a spectacular thought for you.

I don't subscribe to the popular attitude of despising the tourist. We are all tourists on this earth. It's merely a question of degree and numbers. If I stand and stare by myself, it is pious appreciation. When there are twenty of us, possibly chattering, we commit an affront if not outright sacrilege.

Mounting an annual exhibition as I do, and very much aware of being in the humanest of communications business, I welcome tourists as indeed I welcome everybody. It has

been said that ultimately a given place means the people in it, and those who have lived there. I drink to that.

In my time I've lived and worked with the full spectrum of social denominations and have encountered the most comprehensive generosity of heart and deed, well nigh without exception. Of course there are bastards to be found and folk that irritate like nettle-rash, anywhere. Who wants a serried company of angels, a bland society devoid of controversial figures? Where has it been set down that life should be easy? God is not a social worker. Only an innate troublemaker could have encompassed Creation.

We've had enough troublemakers, plague-spots and eyesores to leaven the character of Edinburgh, which else might so easily have come to stand for a monument to gracious provincialism – yes, that's how handsome it looks.

The arts are rife here ranging from the humdrum to the wildest: and last but not least, here is where my children were born, so that to this day I ritually salute the Simpson every time I pass the Meadows.

August 1992

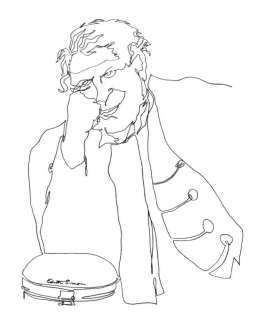

Philip Caplan QC 1974
continuous-line 24 x 16ins

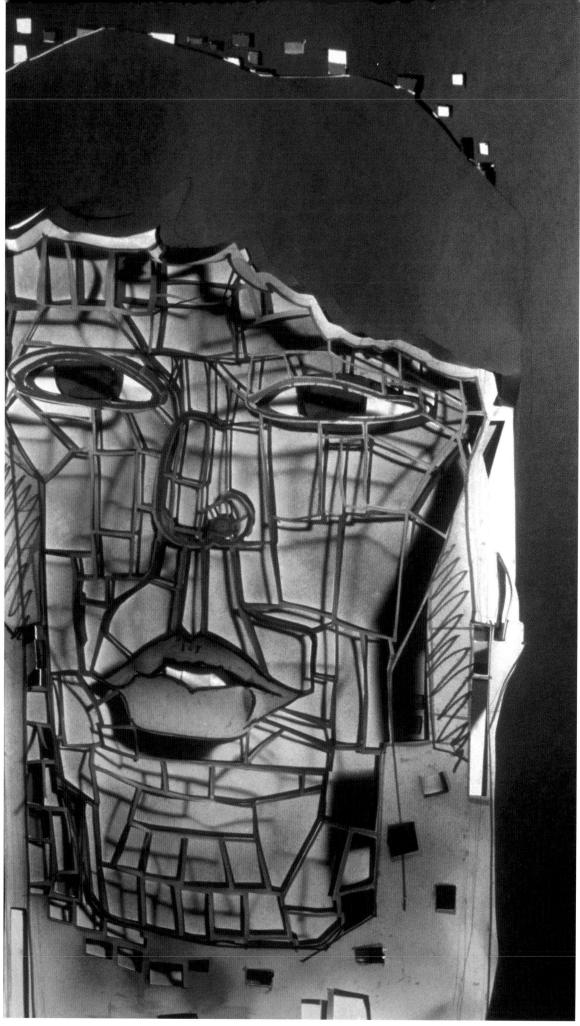

Tom Stoppard 1979
five colour layers and ink 24 × 12ins

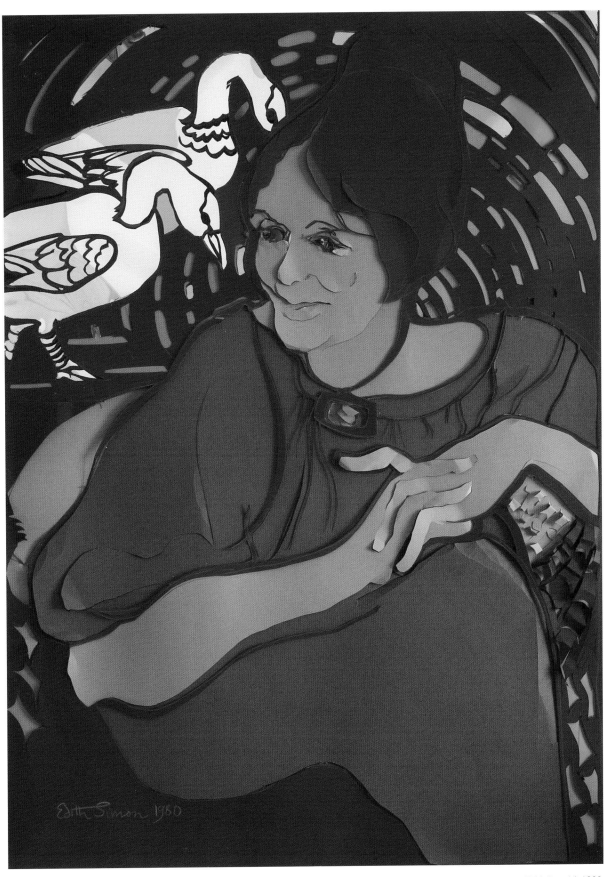

The Watchers (Edith Revely) 1980
six colour layers 30 × 27ins

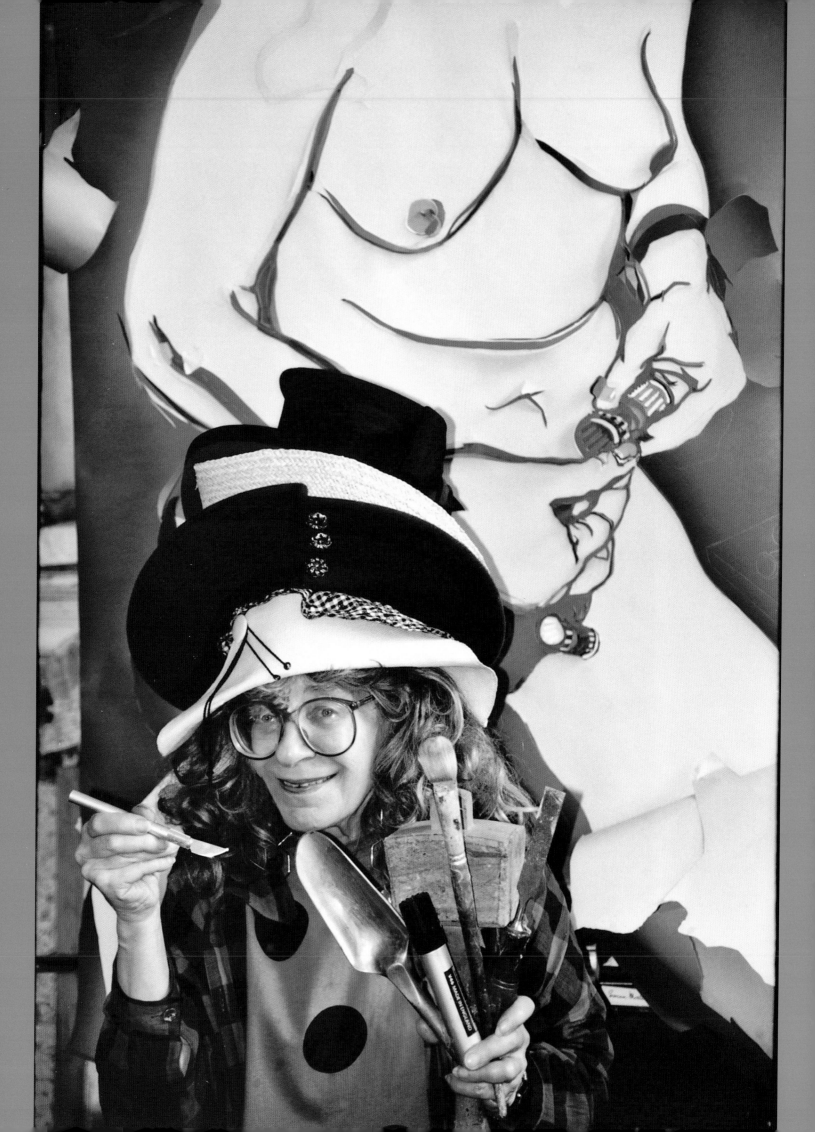

EDITH SIMON'S ART
by giles sutherland

EDITH SIMON'S ART
by giles sutherland

1 INTRODUCTION

Edith Simon's life brilliantly encompassed a number of careers: book illustrator, graphic artist, novelist, historian, translator, essayist, painter, sculptor and draughtswoman. Her output was prodigious and prolific – her career as a writer alone would have satisfied more modest talents. However, in her late forties she turned from writing full-time to making art, an occupation that again turned out to occupy her time and talents fully. A catalogue of more than eight-hundred extant works in a wide variety of media testifies to her passionate dedication to developing her art.

In the minds of most, Edith Simon's work will be remembered for the medium in which she excelled and had developed and made her own – the 'scalpel-painting'. Simon had originally termed this 'papercut bas relief', but for good reasons opted for a much more vigorous and slightly threatening label. The technique is explained in more detail below but essentially involves using successive layers of cut paper to create images. The images have a three-dimensional quality that becomes more pronounced when viewed under specific lighting conditions.

In an undated manuscript written around 1976 Edith Simon set out some of her ideas for a book which she hoped one day to write about her own idiosyncratic approach to art-making. The sub-title of the proposed work was 'An Art Book with a Difference'. The short text, with its didactic and discursive approach, is revealing of the artist-author in a number of ways:

In the beginning was, not the word, but image. Visual art gave birth to language, religion, ideas, science, technology: the lot; and from the first accidental hand print till the coming of photography and wireless transmission, the artist worked for people … But then the camera imposed a rigid template on the world of appearances and the new media gradually monopolised communications. The third eye, that sees beyond immediate appearance, became dimmed; older arteries of communication grew clogged. The artist and his audience ceased to be in step. People became 'other people', no longer tacitly including the image-maker himself, who now had to say, in effect, 'To hell with you, I'm doing my thing' or perish.[1]

Simon discussed what she believed also to be an unique aspect of art: the ability to see beneath the surface of the thing itself. Simon's philosophy of art-making is important in another aspect. It introduces the idea of the audience as a crucial component of her approach. Art does not need an audience to exist; but it does need one in order to be shared. By way of explanation for her gradual move from writer to visual artist she contrasts the isolation of the former with the more public exposure of the latter:

The slow sometimes isolated and sometimes non-existent feedback from books contrasted with the instant and immediate apprehension of the purely visual object. Although in all these lines of endeavour one starts out without an audience and is in no way deterred by this, the tremendous new stimulus of an unexpected audience … helped … me to express what I felt I had to say about life … in … compact visual shorthand …[2]

In an age where the specialist is revered and the generalist regarded with some suspicion, Edith Simon was a maverick figure. She had never baulked at the idea of challenging convention:

I was … trying to do what I most wanted to do in the teeth of a then ruling fashion that led me to the techniques by which I learned most and which in other ways too became rewarding: paper-cuts, continuous-line, rope sculpture, plastics.[3]

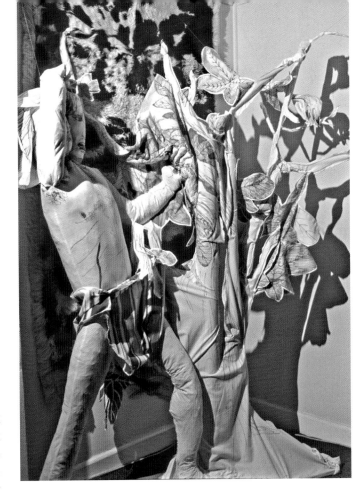

Jesus and the Fig Tree 1972
mobile sculpture 90 × 60 × 18ins

The focus of this short study is, therefore, Simon's work as an interpreter of religious themes and as a portraitist; these two areas bring her fascination with people together with her passionate historical, philosophical and spiritual interests. Such a study, confined by space and time, cannot do justice to the entirety of Simon's oeuvre as a visual artist; the approach has been to prioritise depth of comment and analysis over breadth.

Many aspects of an artist's life can inform their art: upbringing, training, family, relationships and life in general. Edith Simon was born in 1917 into a Germany that was at war; the privations of that society and economy were part of her familial experience. Her emigration to England at the age of fifteen was a common experience for many Jewish middle-class intellectual families. This diaspora, although tragic on one level, made our society all the richer.

Edith Simon did not suffer personally during the rise of National Socialism. However, even though she records no anguish or fear at the experience of leaving Germany (she returned within months to complete her *Reifezeugnis*) her work was informed at a sub-conscious level by events she witnessed or heard about. In terms of early artistic influence the works of Helmut Hügel (one of whose works Simon's parents owned), Lovis Corinth and Oskar Kokoschka had a strong effect. Throughout her life the artists of the Renaissance also held a great interest. Indeed, one of the treasured moments in Simon's career was when she visited the Sistine Chapel (then under renovation) and was invited to climb onto the scaffolding to look at Michelangelo's masterpiece up close and to 'touch the hand of God'. But a good artist wastes no experience in the pursuit of their art and all facets of Simon's world informed her work; and much also formed its subject matter.

Simon's work has been widely collected, indeed to such an extent that only around forty works remain in the possession of her family – the rest have been dispersed to an avid and enthusiastic audience of collectors around the world, from public institutions to private households such as that of Alison Elwell-Sutton whose collection is both highly representative of Simon's work, yet unique and deeply personal. Public collections include The University of Edinburgh, the John Innes Centre (a posthumous portrait of Sir Rowland Biffen, founder of the Plant Breeding Institute,

Cambridge) and The City Art Centre, Edinburgh. It is, therefore, one of life's curiosities that at the time of writing none of Simon's work has been bought for a national collection. This despite specialising in portraiture for three decades in a city whose Scottish National Portrait Gallery purports to reflect the activities of its artists and citizens.

2 RELIGIOUS THEMES

Although Simon's artistic output has ranged over a wide number of media and explored an equally diverse variety of themes, particular constants have re-occurred at regular intervals throughout her career. One of these is her treatment of religious subject matter; this particular fascination has also been apparent in her career as a writer. Her novels and historical studies have included titles such as *The Golden Hand*, *The Reformation*, *The Saints* and *Luther Alive*. A number of key works deserve particular mention.

'Jesus and the Fig Tree' (1972) illustrates the passages in the Gospels of Matthew and Mark where Jesus 'curses' a fig tree in the presence of his disciples:

Now in the morning as he returned into the city, he hungered. And when he saw a fig tree in the way, he came to it, and found nothing thereon, but leaves only, (Mark 11:13 for it was not the season for fruit) and said unto it, 'Let no fruit grow on thee henceforward for ever.' And presently the fig tree withered away. And when the disciples saw it, they marvelled, saying, 'How soon is the fig tree withered away!' Jesus

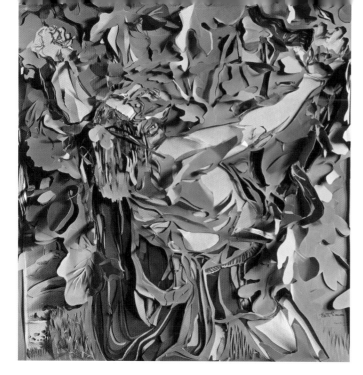

Jesus Cursing the Fig Tree 1991
scalpel-painting seven colour layers
38 × 36ins

Corinth Crucifixion – Das Grosse
Martyrium Lovis Corinth 1907
Museum Ostdeutsche Galerie,
Regensburg, Germany

answered and said unto them, 'Verily I say unto you, If ye have faith, and doubt not, ye shall not only do this which is done to the fig tree, but also if ye shall say unto this mountain, be thou removed, and be thou cast into the sea; it shall be done.'[4]

Theological interpretations of this event differ; some believe the fruitless tree was used by Jesus as a parable or metaphor for the nation of Israel. Simon saw the passage as representing Christ's fallibility and earthliness:

The incident of Jesus cursing the fig-tree was always of particular interest to me because as far as I know it's never been depicted in religious art ... in interpreting it people usually skate over it ... but in contrast with all Jesus' other actions being a pure tantrum, as it were, [it is] the behaviour of a man in conflict and obviously extremely worried ... it seems to me to be the nearest thing to factual evidence of such a person.[5]

The theme and the questions it poses are important, leading Simon to give the subject a more compelling reworking in 1991, 'Jesus Cursing the Fig Tree', lending further credence to the argument that scalpel-painting is a more powerful and forceful medium.

The majority of the viewing public and the critics received Simon's textile work favourably and enthusiastically. Writing about Simon's 1973 'Adventure Show' at The University of Edinburgh's Chaplaincy Centre, Martin Baillie observed:

These sculptures make the show and if they are not art, then one can only paraphrase a comment of David Hume on philosophy, so much the worse for art. I enjoyed this show enormously ... Adam and Eve tasting the forbidden fruit on a green sward thrown over an iron bedstead; a monument to a well known art impresario complete with column and goat; an elegant seated dancer; Beethoven and Mozart as a child prodigy ... the Annunciation with the Virgin kneeling, one hand to her breast, the

other with nervous fingers plucking at her robe – this, in its fashion, is as moving as medieval painted-wood sculptures.[6]

The following year *The Observer* gave an upbeat notice of Simon's 'Open House' show at the Andsell Gallery, London which it described as 'by far the wittiest, most flagrantly frivolous art show in London for some time'. The reviewer continued:

Mrs Simon ... works with the most unlikely materials, mainly on theatrical or erotic themes ... most appealing are her life-size, rather rag-doll figures made of stuffed delicately-painted canvas – a huge Beethoven ('The Deaf Man') standing silently next to a piano at which sits a tiny figure of Mozart behind the score of a sonata; a couple sewn together at the lips and groin. The bath at the gallery was painted by Mrs Simon with a nude girl inside and another climbing out up the wall and over the tiles; and most spectacular of all are two large armchairs with quilted upholstery – a male and a female nude painted sitting on each one.[7]

Despite the prevalence of such favourable reaction, other observers seemed less convinced. Reviewing Simon's work on BBC Radio, David Miller noted, somewhat testily: 'How else could they [the life-size dolls] be described? Fun pieces, perhaps? I can't take their limp uncertain forms seriously, and they could, through time, degenerate to something akin to a soiled eiderdown.'[8]

Such opinions were in the minority and can be seen as the outmoded opinions of commentators who still, apparently, viewed Simon's blend of sculpture and craft as 'women's art' and as such was seen as being inferior to the then predominantly male pursuit of the 'fine' art of painting. Such blinkered views may, in part, be explained by the peculiarly snobbish British attitude of valuing 'art' over 'craft'. While the former is often revered as the product of unique processes, the latter has frequently been seen as an 'artisan's' activity, reproducible if only the necessary skills could be acquired. The views of Miller, and others, highly prevalent in the early 1970s, may also partly be explained by that fact that such textile work could be safely relegated to the 'lower' realm of 'women's art' and were, therefore, taken less seriously than paintings and sculpting in more 'traditional' materials such as metal and stone. The work of women artists such as Magdalena Abakanowicz, Paula Rego and Judy Chicago – all of whom have used textiles with great power – constructs

Crown of Thorns 1973 rope sculpture (in St Mary's Cathedral, Edinburgh)
resin-reinforced sisal rope 100 × 36 × 24ins

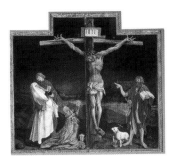

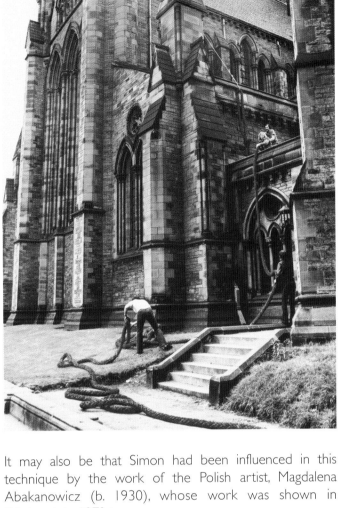

Magdalena Abakanowicz's
rope sculpture linking
St Mary's Cathedral and
the Demarco Gallery Atelier 72 1972

Grünewald crucifixion –
La Crucifixion, Matthias
Grünewald 1512,
Isenheim Altarpiece,
Musée Unterlinden,
Colmar, France

an overwhelmingly powerful case against such attitudes. Like these artists, because of her inherent skill as an object-maker and her gifts of observation and draughtsmanship, Simon was able to bridge the gap between the so-called crafts on the one hand and the 'fine' arts on the other. Simon's rare ability in this area has been seldom recognised. Art critics, generally raised on a diet of the academicised fine arts have been, therefore, both unable and unwilling to give Simon's work the notice it has so clearly merited. One exception to this more or less hard-and-fast rule was W Gordon Smith who centred an entire programme around an examination of Simon's figurative textile sculptures in 1973. Such a treatment obviously signified that, in at least one case, proper notice had been given to the work of a remarkable and unique artist.

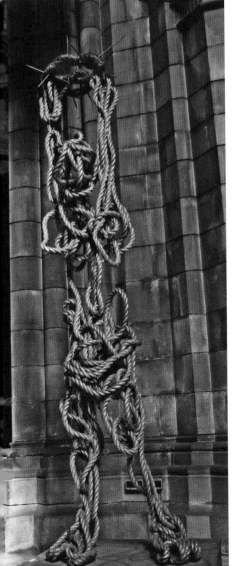

In 'Crown of Thorns', a three-dimensional study of the Crucifixion,[9] the medium is a single coil of rope, solidified in a particular position to create a three-dimensional effect where the 'negative' empty spaces are as important as the 'positive' filled ones. The rope sculpture – a technique which Simon pursued for a number of years in the 1970s – is a logical extension of the continuous line. Explaining her fascination with this method Simon commented:

It seems to lend itself very well to expressing movement … The discipline of having to get round the object in an unbroken line forces concentration … you've really got to consider what you are doing and how you are expressing form …[10]

It may also be that Simon had been influenced in this technique by the work of the Polish artist, Magdalena Abakanowicz (b. 1930), whose work was shown in Edinburgh in 1972.†

Abakanowicz's imagery was typically dark and suffused with images of suffering. Additionally, the Polish artist's choice of subject matter may have also influenced Simon's approach – even at a sub-conscious level. Stylistically there are also links, as Abakanowicz's work is figurative and deeply expressive, as is Simon's. Scotland, traditionally averse to such dark, painful imagery, undoubtedly found works such as 'Crown of Thorns' difficult to stomach, given the nation's preference for the kind of *belle peinture* espoused by the Edinburgh School in the first half of the twentieth century. One notable exception to this general rule is John Bellany, whose early paintings tapped directly into the kind of pain, suffering and violence which *belle peinture* implicitly denied. It is perhaps no coincidence that Simon was a some-time admirer of Bellany and completed a portrait of the artist and his wife in 1989. Simon's choice of imagery and the force with which it is expressed would seem, therefore, to have much more in common with the northern European and particularly German tradition of image-making. Matthias Grünewald's altarpiece for the Monastery of Saint Anthony in Isenheim

† 'Atelier '72' – Exhibition of Polish Art presented by The Richard Demarco Gallery at the Edinburgh International Festival, 1972. Dr Eric Reeve comments: 'I remember her waking me up in the middle of one night early in 1972 and saying 'I must have some rope'. So, I promised to search Edinburgh and if necessary further afield for her. Next morning I found a retail rope seller named Ross & Buncle in Edinburgh, and after I had explored the shop and found they supplied a variety of types and thicknesses of rope I took Edith Simon along there. Edith was very pleased with the materials, and ordered a good sample. These ropes were despatched to us on 27 April, 1972, and included 25 yards of Sisal rope which Edith converted into a tiger, the rope remaining uncut.' Dr Eric Reeve, letter to Giles Sutherland, October 2004. As this date precedes the opening of 'Atelier '72' by several months it seems reasonable to suppose that Simon's exploration of the technique was arrived at independently of Abakanowicz, however, subsequent influence cannot be ruled out.

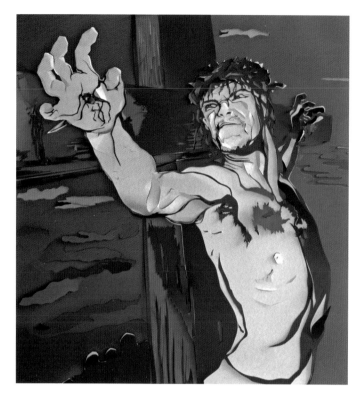

Crucifixion: An Alternative Scenario 1989
scalpel-painting six colour layers 38 x 35ins

can be said to represent this tradition of iconic pathos and Simon's work – with its conscious and sub-conscious roots in the Germanic tradition – must be seen in this context.

Further explaining her approach Simon commented: 'The whole point of the Crucifixion was the voluntary sacrifice so that suffering by itself seems not enough in referring to it. So here is Christ crowning himself with a crown of thorns rather like Napoleon when he made himself Emperor …'[11] In the New Testament it is, of course, others who 'crown' Jesus:

Then the soldiers of the governor took Jesus into the common hall, and gathered unto him the whole band of soldiers. And they stripped him, and put on him a scarlet robe. And when they had plaited a crown of thorns, they put it upon his head, and a reed in his right hand: and they bowed the knee before him, and mocked him, saying, Hail, King of the Jews! And they spat upon him, and took the reed, and smote him on the head.[12]

By transforming a passive event into an active one Simon reinforces the idea of self-sacrifice – an action, in effect, willed and sanctioned by Christ himself. Much of the force of this work however derives from the apparent tension created by the medium and its subject matter. Rope is traditionally associated with execution by hanging and indeed one of the earliest extant artistic images of the Crucifixion – an ivory relief dating from c. 420–450 – shows Christ on the cross, adjacent to the figure of Judas, hanged by a rope. The confounding of expectation, even by subliminal methods, is a deliberate technique employed by Simon to create the jarring, uncomfortable sensation experienced when looking at 'Crown of Thorns'.

'Crucifixion: An Alternative Scenario' (1989) is a natural successor to 'Crown of Thorns', executed as a scalpel-

painting. Since the early fifth century, depictions of the Crucifixion had become common in western art. The subject has held a fascination for artists as diverse as William Blake, Titian, Tintoretto, Albrecht Dürer and Francis Bacon. It is a truism that each artist brings his or her own interpretation to such a subject and these representations are inevitably the result of prevailing contemporaneous factors such as social context, purpose and fashion. The early twentieth century saw a new kind of realism entering the treatment of religious subject matter, best typified in terms of the Crucifixion by the German artist, Lovis Corinth (1858–1925). Corinth's raw, uncompromising handling undoubtedly appealed to Simon and it has been observed that the artist had an influence on Simon's early artistic development.[13]

Simon takes Corinth's approach and develops it. Unlike most depictions of the event, Simon's does not attempt to encompass the whole story in her scenario but, instead, focuses on Christ himself. Inge Goodwin, the artist's sister, has pointed out Simon's method by stressing that 'the idea of 'An Alternative Scenario' is that Christ had the power to save himself and descend alive from the Cross, rejecting his own crucifixion. Instead he chose the Crown of Thorns and the Cross to fulfil His (God's) purpose and save Mankind.'[14] Most images of the Crucifixion locate the artist and viewer at 'ground level' so that the figure of Christ on the cross is elevated; and, as a corollary, the audience must look up, both figuratively and literally, to observe the event. This approach relates to the elevated concept of 'Christ in Majesty'. Simon turns this convention around by positioning the audience (and herself, as artist) at eye-level with Christ. We are therefore obliged to read the work in a way that is essentially different from many other artists' treatments. By looking the crucified figure in the eye, Simon brings us close up to the harsh, brutal reality; this is akin to cinematic technique where a camera mounted on a 'cherry picker' moves in and up towards a figure. Part of the considerable power of this work derives from the pervasive feeling that Christ, should he wish, could pull the nails from his hands and free himself.

How do we gauge when any artist has reached the apogee of his or her career? This is a complex question because implicit in any answer is the idea that all preceding work is merely a series of stages (presumably ever-improving) on the

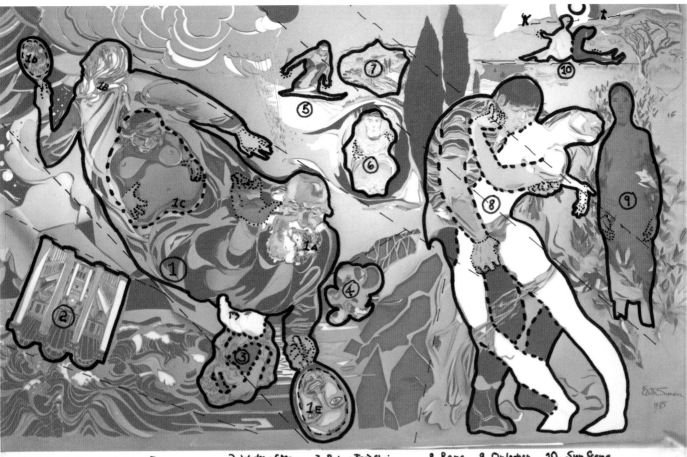

1. God – A, Darwin ; B, Leonardo 2. Works of Man 3. Baby + Food Chain 8. Rape 9. Onlooker 10. Sun Scene
 C, The Birthgiver ; 4. Octopus 5. Skier 6. Freezing
 D. Figure Reflection; E. Reverse Reflection 7. Tuscan Landscape NB. small dotted lines show hands

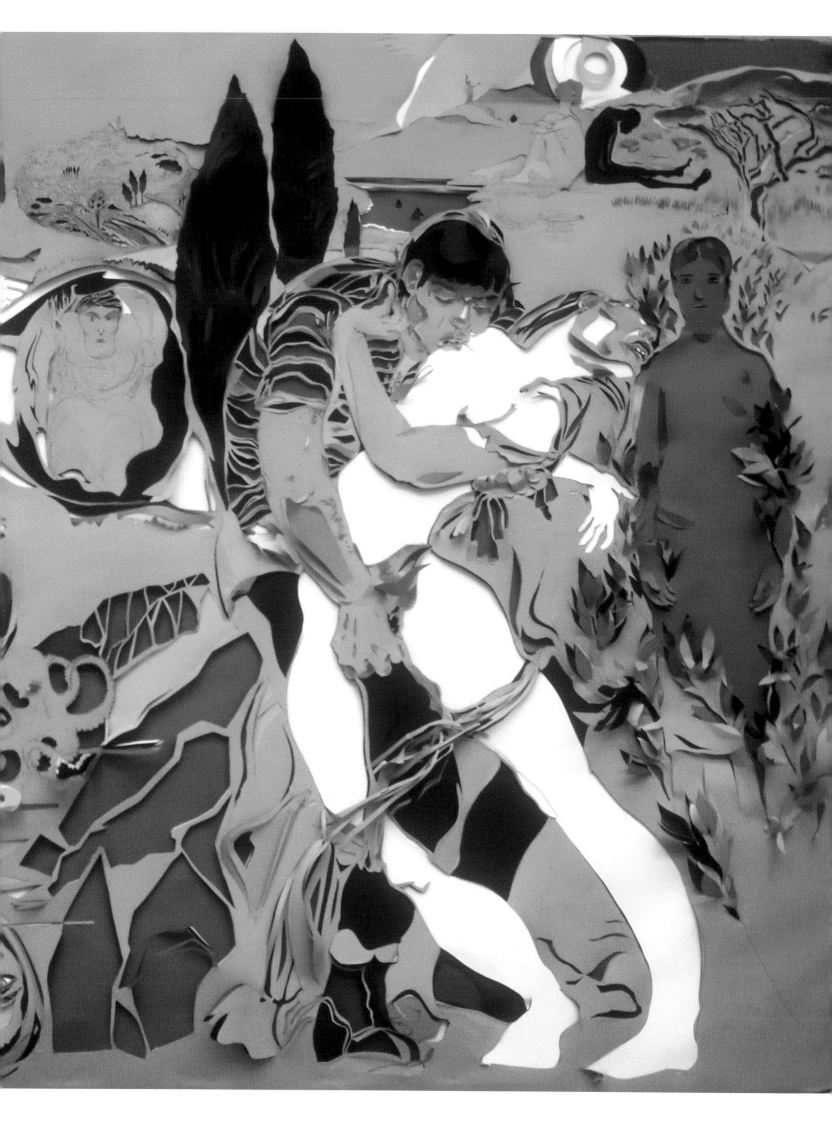

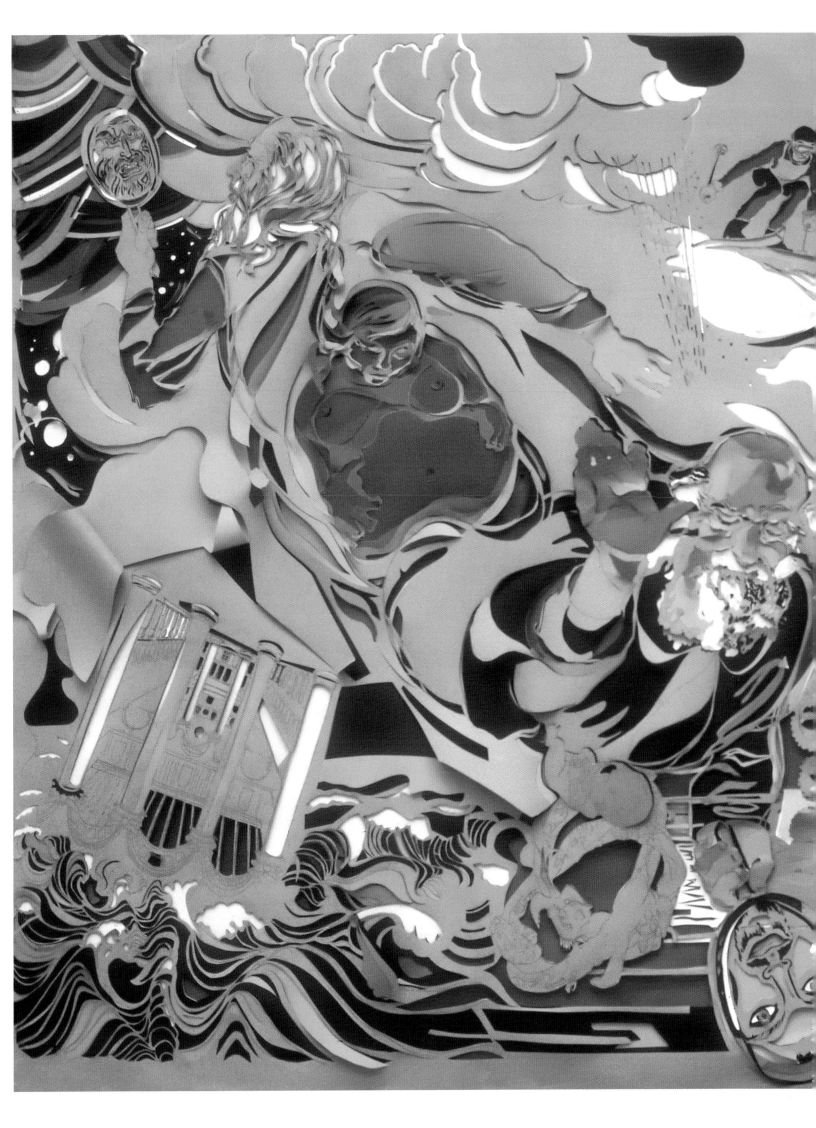

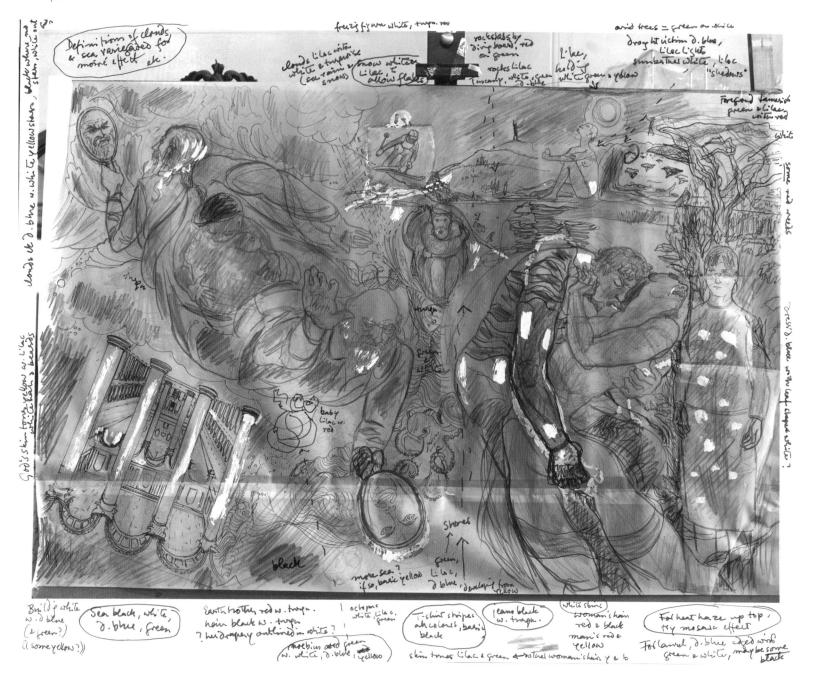

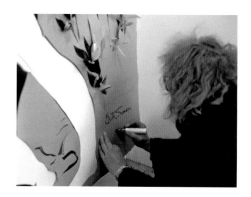

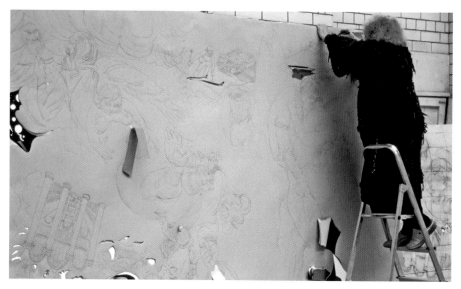

Edith working on the Creation

path to aesthetic truth while all following work is in some kind of decline, reached after a highpoint.

Without wishing to imply or assert either of these notions it is, however, possible to state that, with the execution of 'The Creation of God and Heaven and Hell', Simon created a masterwork which was more ambitious and complex than anything she had made previously.

Limited only by the power of her own considerable imagination and the constraints of space imposed by the studio, Simon nevertheless created a significantly-sized work (measuring 6' x 10') whose physical scale was matched by the complexity of its design, composition and content.[15] Discussing the Judeo-Christian mythology of the Creation (and in her characteristic style) Simon explained some of the thinking behind the work:

Possessed of such unbounded inventiveness as confronts us everywhere in nature, such a Creator would never have been content to fashion humankind after an existing prototype in his own image. No, it was the limited imagination of Man that saw the needed deity as a mere magnified reflection of himself, for better or for worse.

This concept seemed a challenging subject for allegory, for a pictorial shorthand statement of something that in words could run to volumes.[16]

In discussion with W Gordon Smith some ten years previously, and elsewhere, Simon had explained her differing approaches to the respective practices of writing and visual art. Although both had similar satisfactions, the notion of immediacy in relation to visual art provided great affirmation: 'You can take someone by the scruff of the neck and say you've got to look at my picture … and they can't help but see it but you can't force anybody to read a book …'[17] The idea of creative urgency and immediate communication had suffused Simon's desire to make 'The Creation' and, as she pointed out, she viewed the work as 'pictorial shorthand' for a complex series of ideas and feelings.

The basic approach of the work proposes that the opposing notions of heaven and hell are two sides of the same coin; and, further, that heaven and hell are entirely subjective: 'For it is soon clear that anybody's personal heaven is likely to

contain hell for someone else.[18] Perhaps this was Simon's attempt to illustrate the Existentialist belief of Jean-Paul Sartre that 'l'Enfer, c'est les autres'.

Simon sets up a number of opposing images and proceeds to unify them pictorially and philosophically through a series of motifs, including the image of the birth-giver and the octopus. In her use of the representation of the earth goddess, perhaps the oldest of deities, epitomised by such ancient sculptural forms as the 'Willendorf Venus', Simon asserts that procreation is the ultimate goal of all life; while the use of the octopus emphasises that, even in the midst of life, death is all around – as the female octopus retires to die after giving birth.

Detail: Rape

Elsewhere in the work a skier plays in the snow and ice while another person freezes to death and, continuing the theme of mutual opposition, a sunbather relaxes while a drought victim slowly dies. The powerful and disturbing portrayal of the act of rape suggests that in the ecstasy of the rapist there is the simultaneous and wholly opposing suffering of the victim. In the act of violation the woman looks towards a laurel bush – this image refers to the Greek myth where the nymph Daphne was transformed into a laurel bush so that she might escape being raped. Yet within the bush there is a lone figure – an onlooker who is neither wholly detached from nor actively involved in the act he is witnessing. Here, Simon seems to be suggesting that the figure represents ourselves: constrained, unable to act, impotent: 'a wistful onlooker – one who is undesired, unfulfilled and thus dwells in heaven and hell, peace and hopelessness, at one and the same time.'[19]

As a writer and artist, Simon took her inspiration and ideas from an eclectic range of sources; she was a wide reader and this life-long passion reflected the interest, love and

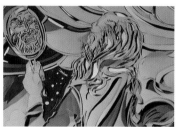

Details:
Darwin
Leonardo

excitement she felt for the world around her. Scientific ideas – as much as the arts and humanities – were never far from her frame of reference; it is not insignificant in this respect that her long, fruitful and supportive marriage was to Dr Eric Reeve, an eminent geneticist at The University of Edinburgh.[20] It is therefore appropriate and consistent that in 'The Creation' Simon employs the images of Charles Darwin and Leonardo Da Vinci to symbolise God and the Creation; they stand for what C P Snow called the 'two cultures' of art and science'[21] here united as one, reflecting the integration of art and science represented by Simon's own marriage. Each of these figures holds a mirror in which is shown, respectively, a serene and a wrathful deity. Emerging from this compound image is a Möbius strip on which the artist has depicted a food chain and cycle of life.[22]

Compositionally 'The Creation' is based on a series of diagonal parallel lines – these consciously echo techniques used by Renaissance masters such as Titian, Raphael and Michelangelo. Structure was important to Simon and reinforces her belief in 'freedom through constraint'. In other words, the discipline of working within an existing set of rules paradoxically allows greater freedom of expression.

Detail: Möbius strip

Through these varied references and the conscious acknowledgement of artistic precursors it would seem that Simon was positioning herself in a respectable art-historical lineage. Such referencing should not be seen as fanciful or over-ambitious; this was acknowledgment of our universal inheritance and her attempt to build upon it.

The desire to express action, emotion and concept in a simultaneous non-linear narrative is by no means without precedent and by implication therefore not an unreasonable ambition. The deliberate lack of a specific focal point allows the viewer's eye to move at will over the work. Simon well understood the idea of structuring the audience's viewing experience, for her exhibitions were laid out with such ideas in mind. Here, however, there is no obvious narrative thread. The intention was therefore to bombard the audience with a number of powerfully charged visual elements seen in no particular order and by doing so suggest the scientific idea of the Chaos of the universe. Techniques of such temporal and narrative distortion were, of course, the basis of Modernism. There is, however, real excitement here in the dynamic expression of ideas, feelings and imagery – a series of qualities which can be found across Simon's oeuvre.

3 EDITH SIMON AS PORTRAITIST

From the evidence of Simon's earliest extant work (including her juvenilia) it is clear that her forte lay in the depiction of individuals. Works such as 'Aunt Cilly', 'Walter', 'Dolly' and 'Inge' reveal a precocious talent – all were completed during her teenage years. Collectively they reveal a flair for observation and an ability to convey more than the bare physical details of the sitter. These are important aspects of a two-fold definition of successful portraiture, as Professor Shearer West has pointed out: 'While a portrait can be concerned with likeness as contained in a person's physical features, it can also represent the subject's social position or 'inner life', such as their character or virtues.'[23] Stylistically, these works owe a great deal to German Expressionism – perhaps an unsurprising fact given Simon's early upbringing in Weimar Germany.

These early works – executed in a variety of media, from ink and wash to oil paint – concentrate on Simon's immediate family. By definition these were individuals whom she knew well and to whom she had easy access. Such an approach is not surprising, particularly when one considers the financial and social restraints then operating on a teenage girl in London in the early 1930s. As well as differing in their respective media these portraits reveal a stylistic development which corresponds to changes in Simon's circumstances and her exposure to artistic training and other external influences.

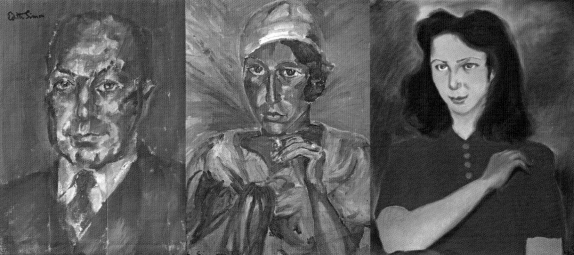

As the artist's sister, Inge Goodwin, points out in her introductory biographical essay Simon briefly attended (on an informal basis) the Düsseldorf Kunstakademie in 1932 and, following that, the Central School of Art and the Slade School of Art in London. Here her precocious and latent talent was exposed and developed but it is not possible to attribute specific stylistic developments in her work to particular teachers or methods taught at the various schools Simon attended. It is however possible to see a movement from a tentative, yet powerful work such as 'Aunt Cilly' (1932), through to the bolder more assertive style of 'Self Portrait' (1934) culminating in the stylised yet haunting image of Inge Goodwin, 'Inge' (1939).

The visual art of portraiture and the literary art of biography, both of which Simon practised, share a number of important qualities. Both attempt to describe an individual in terms that extend beyond mere surface information; biographies often contain visual portraits (photographs, paintings etc.) and portraits often contain visual clues as to the status/occupation of the sitter, even to the extent of sometimes using written information in the work itself to convey additional information. However, whereas a portrait nearly always deals with temporal stasis, a written biography often includes the entire course of a person's life. It is no mere coincidence that Simon excelled in both; for a time they were complementary activities but as Simon's long and distinguished career as fiction writer, biographer and historian waned, so reciprocally her career as a visual artist evolved. There had been almost a thirty-year gap in Simon's activities as a visual artist, although she did pursue visual art on a part-time basis, describing herself quite literally as a 'Sunday painter'.

Between the late 1930s and late 1960s Simon's artistic productivity, although limited in relation to her subsequent prolific output, amounted to over a hundred recorded works (but there were obviously many more). As Inge Goodwin

points out these works were done at a time when Simon was engaged in a full-time career as a writer as well as bringing up a family of three children. Her achievement as an occasional painter and artist is therefore not insignificant given the strictures within which she operated. The majority of these works are portraits and studies of people (the two genres, it should be noted, are distinct). They show dancers (studied from life at a nearby ballet school), family members and friends. They range across a number of media but comprise mostly drawing and painting. A study of a young woman 'Hair Dryer' is perhaps typical of Simon's approach at this time.[24] It shows a reclining figure in a slip with a towel wrapped around her head – indicating that she has recently bathed. The work is sensitive and conveys something of the character of the woman in question, in particular, her erotic sensual beauty. The setting is stylised and the floral background adds to the impression of delicacy and femininity.

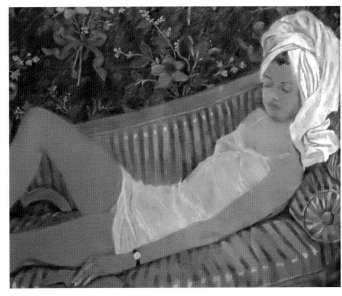

Hair Dryer 1959 pastel 44 x 30ins

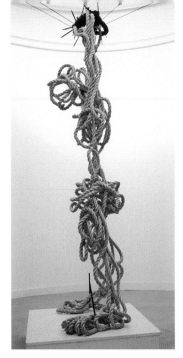

Crown of Thorns 1973 rope sculpture
(at Talbot Rice Art Gallery)
resin-reinforced sisal rope
100 × 36 × 24ins

Sleeping Beauty (Lesley Bandy) 1967
scalpel-painting two colour layers
34 × 22ins

Commissioned book jackets 1935–7

Inge Goodwin notes that Simon's earliest scalpel-painting, 'Sleeping Beauty', dates from 1967. Inevitably these early essays in a medium which is, apparently, unique to Simon were unsophisticated by her later standards. Another early work in the same medium entitled 'Hatted Girl' again shows the emergent technique.[25] Completed in three colours the work displays many of the facets which Simon was to develop more fully in later years. The portrait achieves a likeness as well as conveying something of the sitter's character: jauntily sporting a cap and necklace the young woman appears as confident as she is fashion-conscious.

It is unclear how Simon first began to develop her technique of scalpel-painting. Its relationship to the more purely three-dimensional technique of sculpture (which she had practised since 1969) is important because it presents a more workable, if no less technically complex, medium. The development of scalpel-painting can also be traced back to Simon's use of the continuous-line;[26] this was explored purely as a drawing technique which then led on, several years later, to sculptural works formed with a single length of rope. Such increasingly adept handling of layers of colour also owe much to Simon's early career as a book illustrator and graphic artist. These skills were certainly enhanced and developed by her early association with the Artists International Association whose members included a number of gifted illustrators and artists such as Alex Koolman and Cliff Rowe.

The starting point of Simon's scalpel-paintings was also a line drawing: preparatory studies always formed the basis of these works and they were almost always executed on large sheets of paper drawn with a thick black marker pen which allowed Simon to concentrate on the more telling features in the subject. Her consummate skill in drawing and sketching allowed these preliminary studies to be completed quickly and effectively with a high degree of accuracy.

Simon often took less than an hour to complete several preparatory studies. Antonia Reeve, the artist's elder daughter, observes that Simon's 'visual memory meant that even if one study was inaccurate in one or other detail (and the majority were very life-like) – she could remember how it differed from the sitter and therefore keep the likeness in the master drawing for the scalpel-painting'.[27]

In 1973, Simon herself explained the approach:

The Continuous-line drawings were the first step, exploring form and leading the eye round the picture in one fluid movement; each drawing consists of a single line, unbroken from start to finish … Invisible masses are caught within the outline, with startling plasticity. Next the Papercuts move into the third dimension with the added amenity of subtle changes arising from different angles of illumination – thus these pictures may be varied even by simply transferring them from one wall to another, as well as by lamps placed in different juxtapositions to them.[28]

Discussing the technique of scalpel-painting, Simon's husband, Dr Eric Reeve has observed:

Wanting to introduce a three-dimensional element into her paintings, she thought of the brilliant and completely original idea of setting up on a hard board a number of sheets of paper, each of a different carefully chosen single colour and each of the same size, and fastened by staples round its edges to the board, which was then held vertically by the easel. A master drawing was traced through to give a faint outline of the picture onto the top layer of coloured paper. This tracing did not remain on the final picture, any visible tracing marks being removed.

Hatted Girl (Jay Reeve) 1972
scalpel-painting three colour layers
18 × 12ins

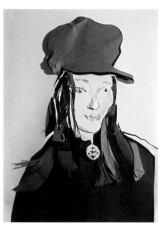

Horse 1973 rope sculpture
resin-reinforced sisal rope
72 × 60 × 34ins

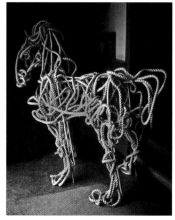

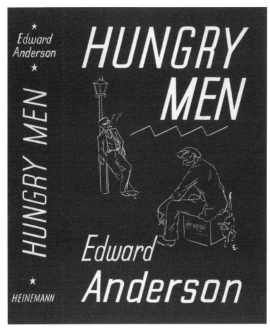

The real work then began, first by revealing a few areas of particular colours required in the final picture cutting through and removing the layers above, and then working through the picture in stages. Numerous scalpels were required, in the form of blades which could be attached in turn to a suitable handle, and important points are: a) it is essential to arrange the colours in the right sequence for the picture, as otherwise it will be impossible to complete due to a particular colour being impossible to bring out at some point where it is needed; b) one would think it almost impossible to complete the whole process without making errors of position or depth in the cutting process, such as would force the artist to start again; yet in the high proportion of her scalpel paintings which I have observed her making as I came and went from our house and looked into her studio very quietly, I have very rarely found that she has made a mistake.[29]

It is important to distinguish Simon's apparently innovatory technique from other related processes such as *découpage*. An art form with a long history, contemporary *découpage* essentially involves creating decorative surfaces on pre-existing objects using paper cut-outs.[30] As Simon's own technique progressed and evolved its methodology inevitably became more complex. She devised a series of self-imposed rules within which she felt bound to operate, advancing her long-held ethos of 'creativity through constraint':

With papercuts, a master drawing is made from sketches. Then the colours are selected. It makes a great deal of difference how many colours there are and in what order they are put together, one on top of the other. The sheets are stapled and placed vertically on the easel. Cutting by scalpel is from the outer, top layer through all the rest, exposing what is needed where. It requires much control and can be very laborious. It often takes as much time in making step by step decisions as in carrying these decisions out. No amount of planning can allow for all the questions and possibilities that arise in the actual process. It is as if the work gradually revealed its secrets in the act of being explored. Each sheet must remain in one piece though perforated,

maybe, to the extent of lace. Portions may be modelled and interwoven, but no separate bits can be cut out and stuck on. The end result goes into a specially constructed frame of the necessary depth and is totally durable.[31]

With portraiture, Simon had clearly found her vocation. It was not an easy route and she felt unable to be both a full-time writer and a full-time artist. Explaining the change in her career she wrote: 'Once upon a time I forsook art for writing, because I did not know what I wanted to say, except in words … When later on revelation struck and I went back to art, I found that my artistic values were unfashionable and my artistic abilities under-developed. To be any good, you have to keep at it, with total application of all your powers.'[32] Simon's realistic attitude in relation to her artistic powers is matched by her commitment, not only to succeed but to excel.

The circumstances surrounding the execution and presentation of a portrait can be complex; involving a sitter, artist, commissioner and audience. However, at the heart of the process, and integral to it, is the relationship between the sitter and the artist. Although constructing a portrait in the absence of the sitter is not rare, it is certainly less common than when the artist and the sitter are in close physical

Matthew (posthumous portrait of Matthew Nelson) 1992
scalpel-painting eight colour layers 43 x 43ins

Kissing the Wind 1979
scalpel-painting seven colour layers
36 x 48ins

proximity, for example, within the artist's studio. One such example of the former situation is Simon's posthumous portrait of Matthew Nelson. Nelson, an admirer of Simon's work, was a gifted student of Computing Science at Stirling University who had died after a long fight with cystic fibrosis. Simon was commissioned by Nelson's parents to complete a portrait of him after his death. At the time Simon recorded that this was the greatest challenge of her career to date. The portrait was based on photographs and her experience of visiting Nelson's home and study.

Simon's favoured location for the initial stages of her composition (a master drawing) and subsequent development where she worked with a scalpel and sheets of coloured paper, was often in her sitters' homes, studios and places of work. It was only in the late 1980s that Simon started to make use of photography as a visual recording medium and to work increasingly from her own studio.

The interaction between sitter and artist is a crucial aspect of portraiture. It is this as much as any other factor (compositional sense, power of observation, artistic ability) which contributes to the success of the work. Simon explained this process as like being 'steeped in hypnotic empathy with the subject for the duration, every time …'[33] Sir Timothy Clifford, who sat for Simon twice, observed that 'Edith asked me to sit for her on two occasions and I was delighted to do so. I suppose I cringed somewhat at seeing my own likeness and didn't buy either piece, mainly because they were large and wouldn't fit in my home. I recall Edith worked very quickly, using a line drawing and photographs.'[34]

My own experience of sitting (or rather, standing!) for Simon was, I suspect, both typical and unique. We had met at an exhibition opening and rather out of the blue she suggested that I sit for her. At the appointed time I arrived (by bike) at her studio in my cycling gear. Immediately she insisted I wear this and pose standing with my bicycle. It was certainly an unorthodox, although entirely welcome, approach. Simon explained that in order for her to work properly I should talk but that she must be silent: '… my sitters are asked to speak while they pose. People go slack and frozen-featured when allowed to sink into ruminant torpor … I like the subjects … to choose what to wear, because of what this will tell us about their self-regard.'[35]

So, for the space of two or three hours, I stood intoning a relentless monologue. I have no recollection of what I talked about but I understood that as well as the visual stimuli set before her she also relied, however subconsciously, on the impression she formed of me through my own speech and mannerisms. Simon spent the time quickly sketching a series of line drawings with a thick black ink marker pen; but she refused to let me see the results. Several months later she had completed the work to her satisfaction and I was invited to inspect it. I can only record my pleasure with the work, particularly the facial likeness, the intricacy of detail lavished on the clothing (gloves and trousers) and of course the presence of my 'prop' – the bike. In truth, I was flattered, not only with the end result but also by being asked to sit in the first place.

On Your Bike (Giles Sutherland) 1998
scalpel-painting ten colour layers 46 x 36ins

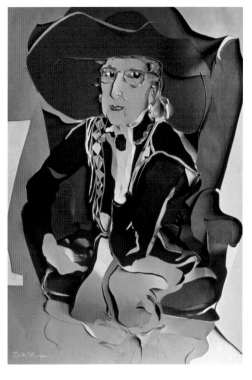

4 A FOCUS ON PORTRAITS

From around 1980 Simon's work increasingly tended towards the medium of 'scalpel-painting' while other media such as video, 'mobile sculpture', 'ropescapes', 'scrollworks', 'see-throughs' and '2½-D pictures' became less prevalent. 'Kissing the Wind' (1979) shows a female figure on all fours partially submerged in water, with tousled hair and head aloft. This is a convincing study and although there appear to be certain technical deficiencies in relation to anatomy, Inge Goodwin explains that 'Edith could be entirely accurate/realistic as to anatomy and proportion, but deliberate stylised distortion for a purpose is surely a component of modern art.'[36] Although not a portrait (it lacks the personalised detail which would allow it to be termed as such) the work's overall composition, balance and increasingly deft handling of the medium (here the number of layers of paper has increased to seven) illustrate the fact that scalpel-painting was increasingly Simon's medium of choice. A much darker work completed in 1983 is a more abstracted, simplified image. It shows a cloaked figure with a skull-like head holding a bag. The apparition – for that is what it appears to be – stands on a pavement or quay in darkness while a strange light illuminates the background. The subject is in fact Sir Gerald Elliot,[37] one-time chairman of the Arts Council. Inge Goodwin comments that 'what fascinated Edith was the conjunction of eye-patch, kimono and handbag.'[38]

Simon was always a social animal; her love of and interest in people and her position as the wife of a well-connected Edinburgh University academic ensured access to a particular stratum of Edinburgh society. Increasingly, members of this circle became the subject of her work and what had previously been studies of people in general became progressively more oriented towards portraiture: studies of specific, identifiable individuals contextualised by their clothes, surroundings and other 'props'.

One such early work is 'The Descent' which shows Andrea Targett-Adams who ran an up-market PR agency, descending a staircase in an elegant Georgian interior. The practice of portraying subjects within a specific setting reflecting the sitter's occupation or social status has a long lineage. Although her formal training in art history was limited Simon, nevertheless, had a highly sophisticated

understanding and knowledge of such matters. Although there is no specific documentary evidence to categorically prove the assertion, Simon would almost certainly have been aware of works such as Marcel Duchamp's 'Nude Descending a Staircase' (1912) and Gerhard Richter's 'Woman Descending the Staircase' (1965) – only Richter's work could approximate to the label 'portrait' (it shows a blurred 'photo-painting' of the opera-singer Maria Callas). Simon's and Richter's works share some startling similarities. They both show elegant, sophisticated and well-dressed mature women descending a flight of stairs. But whereas

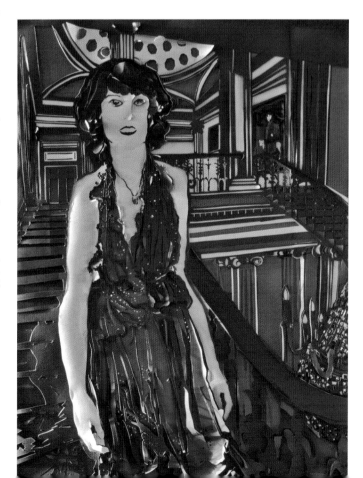

Lord John McCluskey 1987
scalpel-painting eight colour layers 48 x 40ins

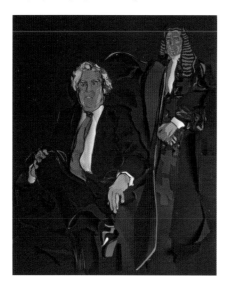

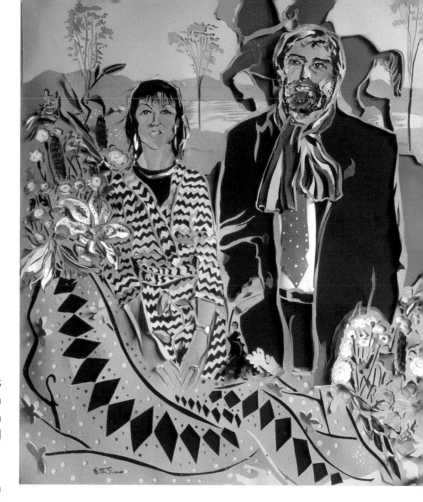

Simon's subject looks straight at the viewer, Richter's take is more tangential. Although the media differ widely, both works portray an identifiable individual within a certain context; and both give a number of clues as to the social standing and preoccupations of the subject.

Dr Elizabeth Mason is a well-known figure in the Edinburgh social and arts scene. She is a colourful personality and has led a full and eventful life.[39] It is therefore entirely apt that such a figure, whom Simon had known since 1947, should form the subject matter of one of Simon's portrait scalpel-paintings.

The portrait shows the sitter – in typical attire – resting in a large red armchair. The subject's head is turned fully to face the viewer and, somewhat atypically for one of Simon's portraits, shows the head disproportionately larger than the rest of the body. This, one can speculate, is a device employed by the artist to focus the viewer's attention on the head, the ultimate focal point of the majority of the artist's portraits. Dr Mason's hat – large, red and extravagant – acts as a device which both illustrates and symbolises the larger-than-life personality of the sitter. However, it would be a mistake to consider the use of red for both the chair and hat as a technical short-cut in the construction of the work. Simon was seldom interested in developing easy solutions. Indeed, it is clear that the opposite was true: she continuously set herself technical challenges which she effectively had to surmount before the work was deemed a success by the artist. The Mason portrait is a case-in-point because the red of the hat and the red of the chair differ in tone: the latter is lighter and pinker in hue than the former. The jarring tonality may have been Simon's method of commenting on what she perceived to be the sitter's personality. Why indeed do something the easy way when a more complex solution would present greater challenges and, as a corollary, greater rewards?

'Lord John McCluskey' (1987), completed at around the same time as the Mason portrait, shows the Edinburgh-based judge, Lord John McCluskey[40] who held the post of Solicitor General for Scotland between 1974 and 1979 and at the time of the portrait was a Senator of the Court of Justice. The work shows McCluskey in two different but complementary roles: one domestic and one professional. Clearly, the sitter's domestic and social role has been emphasised by showing Lord McCluskey seated in a relaxed pose; to the rear, smaller in scale, and tonally more subdued is his professional self. He is attired in formal dress, including the long robes and wig which form part of judicial regalia. The clearly distinct juxtaposition of the two 'selves' is a useful device – although not without precedent. Paul Wunderlich's portrait of George Sand, for example, presents two 'faces' of the nineteenth-century novelist.[41] However, in Wunderlich's work one of the faces is blank, prompting Richard Brilliant to observe: '… identity and naming are inextricably bound together in portraiture … the picture implies a dialectic, turning on the name, that logically requires the viewer to be far more cautious about taking portraits, any portraits, at face value …'[42] Although it would be difficult to argue that Simon's work sets up a dialectic, the portrait does allow simultaneous comment on and portrayal of two entirely separate roles: public office and private citizen.

As Simon's reputation grew and her work became more confident and ambitious, her talents as a portraitist became increasingly in demand. Often, work was created on the basis

A Bouquet for Helen and John (Helen and John Bellany) 1989
scalpel-painting nine colour layers 46 × 42ins

Through a Glass Brightly (Sheena MacDonald) 1989
scalpel-painting nine colour layers 36 × 48ins

of commissions, either mediated by a third party or directly from the sitter or sitters themselves. In relation to the genesis of the portrait of John and Helen Bellany, Simon commented: 'Motivation, format and title for this double portrait burst upon me in one lightning stroke, in joyful reaction to a new phase in John Bellany's paintings … The key colour, too, was in the package. It could not be anything but yellow, partly in compliment to the subject, partly because yellow seems to me to touch off the phantasmagoric nerve in me.'[43]

Simon considered situating the couple amid Bellany's art works or showing Bellany himself in the acting of painting (as she had done previously in her portrait of Sir Robin Phillipson) but that seemed too literal an approach. The portrait was essentially a tribute to the Bellanys' marriage and to John Bellany's status as a respected painter – thus the idea of a floral tribute, included in the title of the work. A number of motifs suggested themselves to Simon in the process of constructing and composing the work. Two derived from the idea of equestrian portraits – a form of high accolade since Classical times. The first specific art-historical reference, seen in the fabric of the sofa in the foreground (and echoed in the patterning of Helen Bellany's dress) was to Simone Martini's fresco of Guidoriccio da Fogliano in Siena.[44] Continuing the equestrian theme, Simon positioned a partial silhouette of Verrocchio's Colleoni statue in Venice behind Bellany's head.[45] The third motif was the addition of what Simon describes as 'wand-land' trees which were common in Renaissance *quattrocento* backgrounds. In a typically light-hearted and modest way, Simon related how these various elements had occurred to her: 'Horse! Equestrian monuments, Society's ultimate accolade … Not a bad furnishing fabric, at that, for something that originated in a sofa. Complete with stylised flowers, leaves, stalks, twigs, moreover, for the 'real' bouquet to shade into. Thank you, Subconscious.'[46]

Simon's portrait of the well-known journalist Sheena MacDonald, 'Through a Glass Brightly', was completed in 1989. The main conceit of the image involves the kind of visual complexity in which Simon delighted – it shows the broadcaster as a reflection in a mirror; beside this mirror image stands a Charles Rennie Mackintosh chair. By implication, we understand the chair to be a prized possession, because although aligned to one side of portrait

it nevertheless assumes an important position in the overall composition. In turn, this prop allows us to attribute certain traits and qualities to the sitter: expensive and cultured taste, the desire to collect and the will to display acquisitions. That the sitter is portrayed before a mirror suggests other qualities: confidence, self-regard and even, perhaps, vanity.

The device of the mirror within a portrait has a long lineage in the history of art. Most famously, perhaps, the mirror was used as a device by Jan Van Eyck in his 'Portrait of Giovanni Arnolfini and Giovanna Cenami (The Arnolfini Marriage)' in 1434. But whereas here the convex reflective surface is used as a way of including the artist himself in the work (and thus recreates the portrait as, additionally, a self-portrait) Simon's purpose is different. The mirror does not show the artist, only the sitter, and again, unlike the Van Eyck there is only one created image of the sitter. Simon, it should be noted, also alluded to Van Eyck's masterpiece, in her double nude portrait, 'Union', which shows a nude couple holding hands with a mirror in the background reflecting the artist.

The Artist in the Studio (Robin Phillipson) 1989
scalpel-painting nine colour layers 51 × 41ins

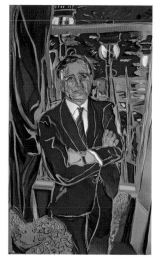

Cliffhanger (Timothy Clifford) 1991
scalpel-painting nine colour layers
50 × 42ins

Reflections (Timothy Clifford) 1998
scalpel-painting six colour layers
43 × 27ins

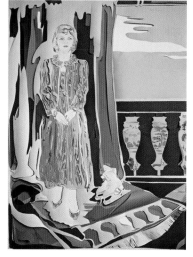

'Die Schöne Müllerin' (Iris Miller) 1991
scalpel-painting nine colour layers
48 × 36ins
This piece forms a companion piece to
Reflections (above).

The Director-General of the National Galleries of Scotland, Sir Timothy Clifford, posed twice as a sitter for Simon – in 1991 and 1998. The first portrait entitled 'Cliffhanger' shows Clifford seated on an armchair which itself is perched vertiginously on the landing of a staircase – the setting is in fact the rear stairway at the National Gallery of Scotland, Edinburgh. The chair appears to be almost ready to topple from its precarious position taking its hapless occupant with it; he, however, nonchalantly looks on, head resting on one arm, legs comfortably crossed. The setting is not unlike the Targett-Adams portrait; above is an elegant cupola, and the Albacini portrait busts. In the foreground and, therefore, correspondingly larger and more prominent, is a portrait bust of Apollo (god of art and war). The tone of Simon's work is characteristically witty and mischievous; the work reveals an ambiguous attitude towards the sitter. She wrote:

... the portrait is a companion piece ... demon king to good fairy perhaps ... in each the central figure occupies a mere third of the total space ... In real life ... the directorial throne does not occupy the physically commanding position it has here – where it could either bar access altogether or eventually come to grief. The latter possibility is denied by the incumbent's attitude, at once imperious and relaxed. Withal there is in his face some vulnerable sensitivity, a soft-shelled nakedness ...[47]

Previously, Simon had hinted at this type of approach: '... [it] ... doesn't mean the portrayal will be all sweetness and light, sugar and spice. Empathy isn't necessarily sweeping approval.

The creative equipment includes a form of X-ray illuminating hidden aspects.'[48] The title of the work, 'Cliffhanger', therefore is a coded message telling us that the artist was well aware of the sitter's political manoeuvring and his apparently precarious tenure of a public office held so idiosyncratically and controversially by its incumbent.

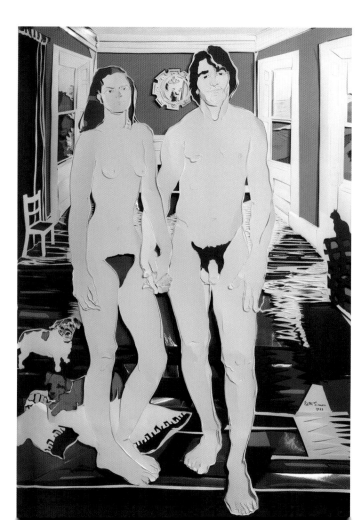

Union 1982 scalpel-painting six colour layers 48 × 36ins

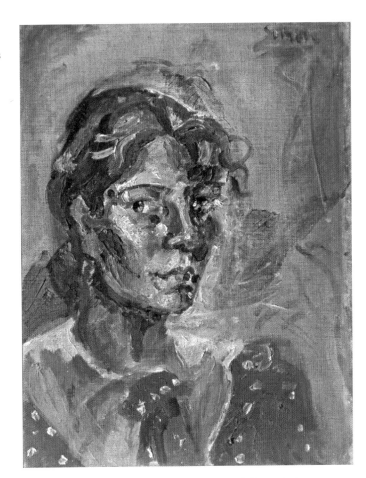

Self Portrait 1934 oil painting 14 × 10ins

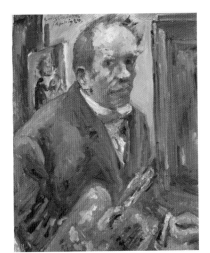

Self Portrait Lovis Corinth 1924,
MoMA New York, © MoMA
and Scala Florence

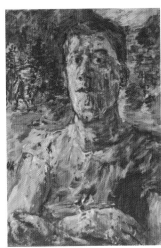

Self Portrait as a Degenerate Artist,
Oskar Kokoschka, 1937
SNGMA Edinburgh
©DACS 2005

5 SELF-PORTRAITS

Throughout her long career Simon completed a number of self-portraits. In terms of art history this sub-genre has, arguably, as long a lineage as portraiture itself. Inevitably, the field is vast; but it is a truism that most figurative artists, especially those who have worked on portraits have, at one time or another, turned their expressive and observational powers away from others and towards themselves.

Edith Simon was, therefore, no exception to this general rule. Her earliest extant self-portrait dates from 1934. This is a compositionally assured work, vigorously executed in thick oils; stylistically it is akin to the work of artists such as Oskar Kokoschka[49] and Lovis Corinth,[50] both artists Simon

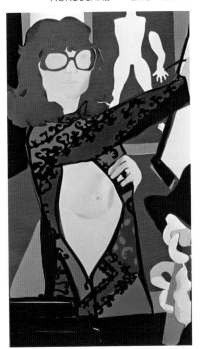

admired. These studies were painted within a decade or so of Simon's own self-portrait and both are perspicacious and revelatory. Physical verisimilitude aside, both attempt to probe the psyche and reach below the surface. Simon's portrait also takes this approach; it is not a mere superficial copying of style and composition. It should be noted that Simon's work was completed when she was only seventeen years of age, while Corinth's and Kokoschka's were painted when these artists were sixty-six years old and fifty-one years old, respectively. Despite

Portait of the Artist 1976
scalpel-painting seven colour layers
36 × 18ins

this, the Corinth portrait especially and Simon's bear some similarities – the angle of the sitter's head in both is similar: slightly askew, and turned in half-profile. But Simon's is a more intense close-up whereas Corinth's field of vision extends to include the various accoutrements of his vocation: easel, brush, and palette. The older painter's occupation and status seem assured while the younger artist is less emphatic and altogether more tentative in terms of defining her self-identity.

A work completed more than forty years later, 'Portrait of the Artist' (1976), takes up where the earlier self-portrait left off. It shows the artist as an artist, complete with easel and pen or brush, in her studio. Here she looks straight out of the image and holds the gaze of the viewer. In a typically erotic gesture, one breast is shown, deliberately revealed and this, at least in geometric terms, forms the centre and focus of the work. Through this physical gesture and, therefore, by metaphorical extension, the artist emphasises the emotional self-exposure inherent in self-portrayal.

Simon returned to the theme of exposure in a work entitled 'What is Truth?' which she described as a 'composite' self-portrait. The eight-layered scalpel-painting shows five separate versions of the artist, all framed within one composition. The question posed in the work's title is a valid one and the issues it addresses are complex. By presenting a multi-faceted view of herself, the artist questions the notion of representation by asking, indirectly, how artists choose to interpret and present themselves. Set within a claustrophobic domestic interior, five 'Ediths' appear to vie for

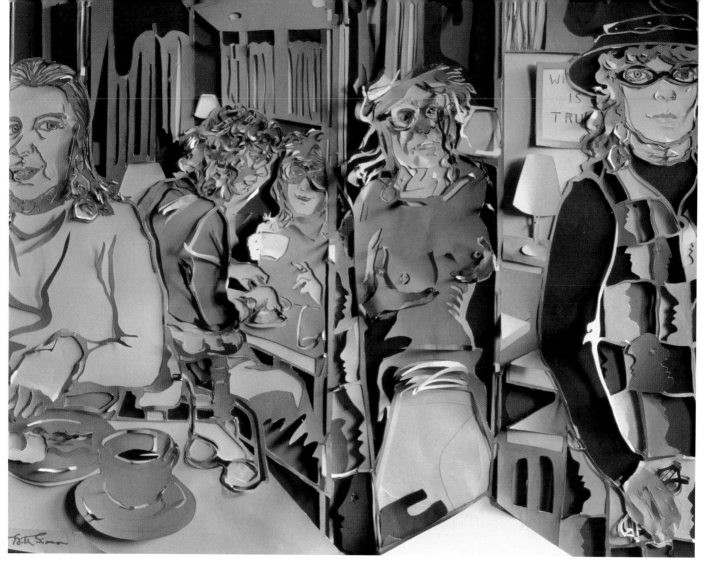

the label 'truth' or, perhaps, 'who is the real Edith?'. Each has a quite separate – but closely linked – identity and each is preoccupied with a distinct activity. On the extreme right is the 'public' face of the artist – fully clothed, with characteristically flamboyant glasses and hat; on close inspection the patterning on the dress is revealed as comprising a series of miniature portrait heads. Although generic rather than specific, they nevertheless point us to Simon's public face as artist. Adjacent to this image is a more tortured and troubled representation. It shows the upper torso and head of the artist; her hair is dishevelled and her facial expression is one of anguish. The figure clasps and cups her unevenly-sized breasts in a gesture of despair and critical self-examination. The frailty and fallibility of the ageing body appears to preoccupy the artist. This is the intimate, private self laid bare, replete with self-doubt and self-criticism. Compositionally, this work is divided into two distinct halves; on the left three 'Ediths' eat, drink, gossip and chat. They look either to the two figures of the 'private' and 'public' self or look back out of the picture towards the audience. In a way, these figures represent the audience too, observing from a safe vantage point the conflicting personae of the artist.

Satire, levity, and a mischievous sense of humour were all effective weapons in Edith Simon's artistic armoury. She uses these tactics to great effect in another self-portrait dating from 1988 ('Edith and the Perishing Wasps') and used for an exhibition poster. This portrays the artist in bee-keeper's guise, complete with helmet and face guard, smiling smugly, safe in the knowledge that the wasps who are attacking her do so in vain. Although they attempt to harm they are unable to penetrate the artist's defences. To anyone with any familiarity with the world of Scottish art it is obvious that two of the faces of the attacking wasps are none other than the former art critic of *The Herald*, Clare Henry. But the tone of this portrait is good-humoured and well-meaning; it pokes fun at the artist herself, as much as the critic. Indeed, Clare Henry, along with a number of other professional critics, had consistently praised and encouraged Simon. Discussing another of the artist's portraits of Clare Henry, 'Clare and Columbines', the critic wrote: 'She draws superbly … I had to wait months till the picture was completed – and I was thrilled with the result.'[51]

Simon loved debate and discourse. Writing in 1991, she effectively sums up a number of essential points about her approach to art:

Looking back, I would say that initially I'd rather floundered, unsure how to express what I had to say in visual terms; whereas with words I'd no such trouble. Later on, with some 17 books to look back on, it struck me that here there was no lasting truthfulness, because in the written

What is Truth? 1992
scalpel-painting eight colour layers
37 x 44ins

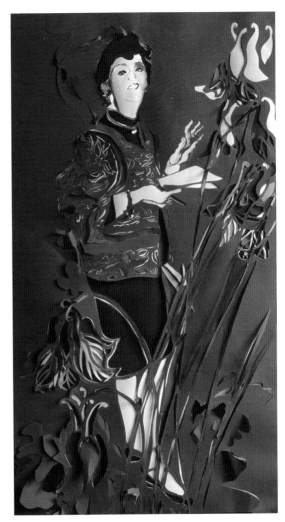

word presentation is selective manipulation, which after a time can lose its validity. You may no longer wish to stand by the former convictions, but couldn't really spend your life rewriting. Whereas with the nonverbal, visual statement every possible interpretation is securely latent for the extracting. People delight me when they find concepts in my work I'd never even thought of.[52]

Edith Simon was a dedicated writer and artist who believed in developing her considerable talents to their utmost. As one of her oft-repeated dictums 'freedom through constraint' illustrates, she continuously devised new sets of self-imposed rules within which she practised her art. Rules were important because they allowed her to set a whole range of challenges – involving composition, media, subject matter and message – which she strove to overcome. In the vast majority of cases, these challenges were met and indeed surpassed.

Her constant curiosity about materials meant that at junctures in her career Simon experimented with different and ever more challenging media. The use of rope to create sculpture and the use of a scalpel and paper to create 'paintings' are two areas in which her success was marked. Both techniques were innovatory and the latter, in particular, Simon made her own. In time, this technique, with all the exciting possibilities it threw up, may come to be seen as being as revolutionary as the use of collage in the early twentieth century. Simon successfully bridged the art-craft divide, creating a synthesis uniquely her own. However, this artistic success was not only predicated on the innovatory use of materials but was also, equally, because of her very considerable talents as an artist. Her strengths lay not just in the surface layers of her work, but also deep below, based on the accumulated experience and mastery of colour, drawing and perspective.

Those who may be tempted to dismiss Simon's art as inferior, or as the work of a 'woman artist' will undoubtedly be forced to revise their opinions. As has so often been demonstrated in art history, the reputations of maverick figures and true innovators, almost always outlive those of their detractors.

February 2005

Clare and Columbines (Clare Henry) 1995
scalpel-painting six colour layers
51 x 30ins

Edith and the Perishing Wasps 1988
oil pastel ink and letratone
28 x 20ins

ENDNOTES

1 'To Hell With You, I'm Doing *Your* Thing – The Making of An Exhibition', undated manuscript, c. 1976

2 op. cit.

3 ibid.

4 Gospel According to Saint Matthew, Chapter 21, verses 18–21

5 Scope, 'The Edith Simon Adventure Show', BBC TV Scotland, October 1973. Producer W Gordon Smith

6 Martin Baillie, 'Round the festival' *Art Notes*, September 1973. The 'monument to a well known art impresario' was one of Simon's characteristically biting and double-edged portraits, laced with satire, which in this instance was a portrayal of Richard Demarco.

7 'Beethoven and the Bath' *Observer Review*, 14 July 1974

8 'Twelve Noon', BBC Scotland, 20 November 1973

9 The 'Crown of Thorns' rope sculpture is in the South Transept of St Mary's Cathedral, Palmerston Place, Edinburgh

10 Scope, op. cit.

11 Scope, op. cit.

12 Gospel According to Saint Matthew, Chapter 27, verses 27–30

13 Inge Goodwin. Interview with Giles Sutherland, September 2004

14 Inge Goodwin. Letter to Giles Sutherland, October 2004

15 *God and the Creation of Heaven and Hell* was made at the Edinburgh Printmakers' Workshop, which afforded more space than her studio.

16 *God and the Creation of Heaven and Hell*, audio-visual by Antonia Reeve and Edith Simon, 1985

17 ibid.

18 ibid.

19 ibid.

20 As Inge Goodwin points out Dr Eric Reeve and Edith Simon shared a house with other scientists at Mortonhall, part of an experimental post-war approach to a community of learning espoused by C H Waddington, a believer in the integration of art and science. See: C H Waddington, *Behind Appearance: Study of the Relations Between Painting and Natural Sciences in This Century*, Edinburgh University Press, 1984

21 The idea that our society is characterised by a split between two cultures – the arts on one hand, and the sciences on the other – has a long history. See C P Snow, *Two Cultures and the Scientific Revolution* (1959)

22 A three-dimensional shape created from a rectangular sheet of paper, posing a visual conundrum – first proposed by Ferdinand Möbius (1790–1868) and used to great effect in the graphic art of C M Escher

23 Shearer West, *Portraiture*, Oxford University Press, 2004, p. 21

24 The subject is Tina Colville, later Lucas, a speech therapist, who lived with the Reeve family between 1959 and 1961.

25 The subject is Jay Reeve aged eighteen.

26 Jay Reeve, the artist's daughter, observes that the techniques of scalpel painting and continuous line drawing developed simultaneously and that although both emerged as distinctive methods in 1967, scalpel painting *preceded* continuous line drawing.

27 Antonia Reeve, letter to Giles Sutherland, October 2004

28 *The Edith Simon Adventure Show*, exhibition catalogue, The Talbot Rice Gallery, The University of Edinburgh, May 1973

29 Dr Eric Reeve, letter to Giles Sutherland, October 2004

30 *Découpage* is a 20th-century word which comes from the French word *découper*, meaning to cut out. Paper cut-outs are reassembled and designed, then glued to a painted or gilded surface. The most traditional technique includes applying 30–40 layers of varnish which are sanded to a beautiful smooth sheen. However, cut-outs may also be applied under glass or alternatively raised to give a three-dimensional appearance. Source: www.decoupage.org

31 *Prospect & Retrospect*, exhibition catalogue, Edinburgh 1981

32 'To be a Pilgrim', text of audio-visual presentation, 1989

33 ibid.

34 Sir Timothy Clifford. Interview with Giles Sutherland, September 2004

35 'ART@EdithSimon-Home', text of catalogue for exhibition at 11 Grosvenor Crescent, Edinburgh, 1999

36 Inge Goodwin. Letter to Giles Sutherland, October 2004

37 The subject was seen by Edith Simon at a fancy dress party

38 op. cit.

39 Dr Elizabeth Mason (b. 1907). See *Cockabully Story: An Autobiography of Elizabeth Mason*, Edinburgh, 2004

40 Lord John Herbert McCluskey, admitted to Faculty of Advocates 1955. QC 1967. Solicitor General for Scotland 1974–9. Senator of the Court of Justice 1984–2000. Reith Lecturer (BBC) 1986.

41 Paul Wunderlich, *George Sand*, c. 1983. Lithograph

42 Richard Brilliant, *Portraiture*, Reaktion Books, 2001, pp. 64–5

43 John Bellany, Scottish painter, born 1942. Following a successful liver transplant operation in 1988 Bellany's work was increasingly executed in a lighter, more colourful palette, in which the colour yellow often predominated. Text of audio-visual presentation 'How Does the Artist Know', op. cit.

44 Simone Martini (1284–1344). Equestrian portrait of Guidoriccio da Fogliano (c. 1328–30). Fresco 340 × 968cm, Palazzo Pubblico, Siena

45 Andrea del Verrocchio (1435–88) Equestrian statue of Bartolomeo Colleoni (1480s), Gilded bronze, height 395cm, Campo di Santi Giovanni e Paolo, Venice

46 Text of audio-visual presentation 'How Does the Artist Know' op. cit.

47 Signals, exhibition catalogue, 1991

48 Lovis Corinth, *Self Portrait*, 1924, oil on canvas, 39 × 31ins (100 × 80.3cm), Museum of Modern Art, New York

49 'Self-portrait of a "Degenerate Artist"', 1937, oil on canvas, 43¼ × 33½ins (110 × 85cm), Scottish National Gallery of Modern Art

50 'Self-Portrait', 1924, oil on canvas, 39¾ × 31⅝ins (100 × 80.3cm), Museum of Modern Art, New York

51 Clare Henry, 'The Art of Talking', *The Herald*, 16 August 1995

52 *Signals*, exhibition catalogue, 1991

The Victory of Prometheus 1990
scalpel-painting nine colour layers
36 x 44ins

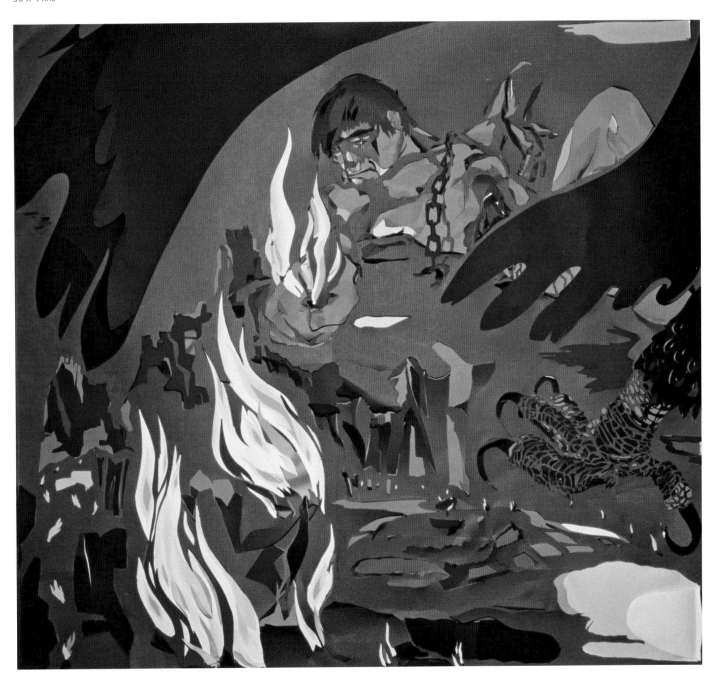

Glut 1982 six colour layers 36 x 24ins

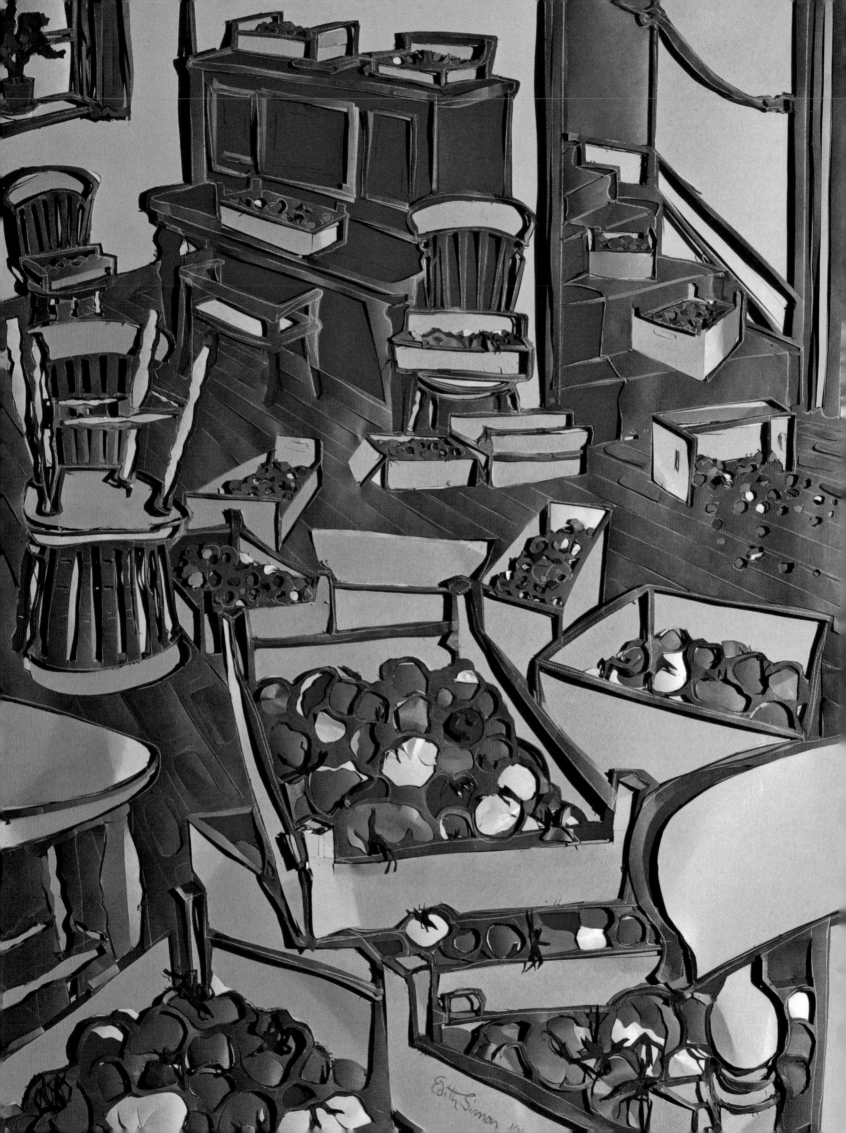

SCALPEL-PAINTINGS
& continuous-line drawings

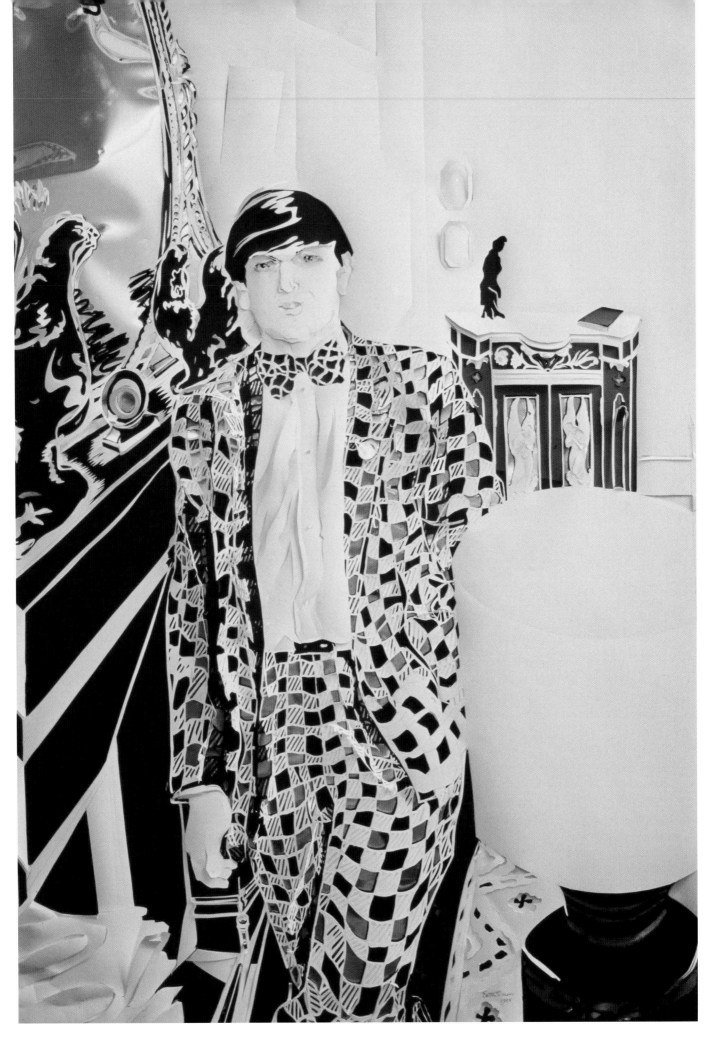

Highlights (Andrew Brown) 1986
scalpel-painting six colour layers 42 x 30ins

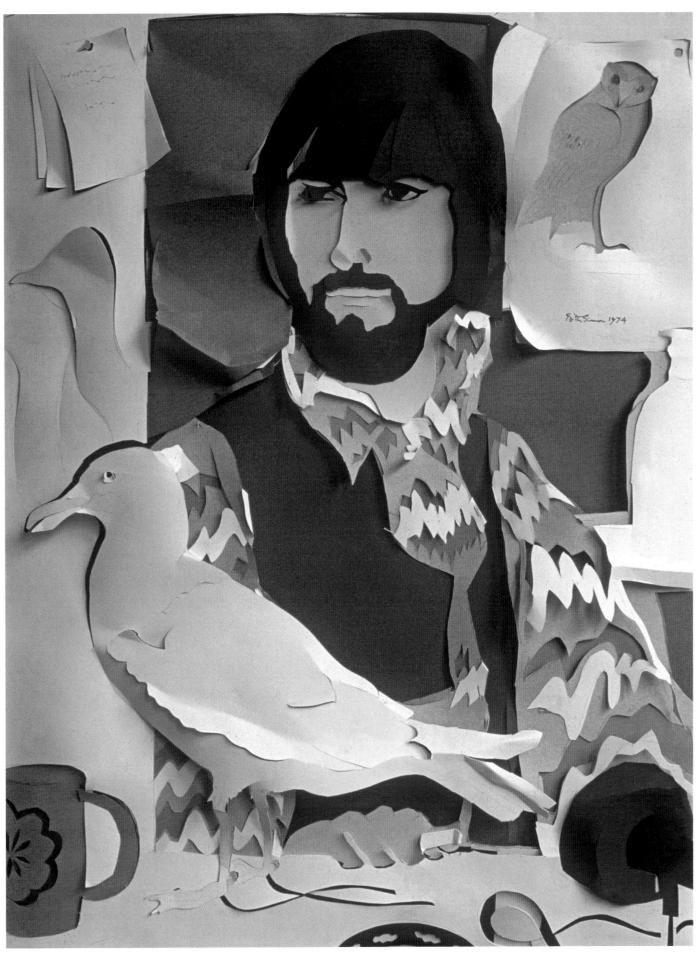

The Taxidermist (Dick Hendry) 1974
scalpel-painting six colour layers 24 x 18ins

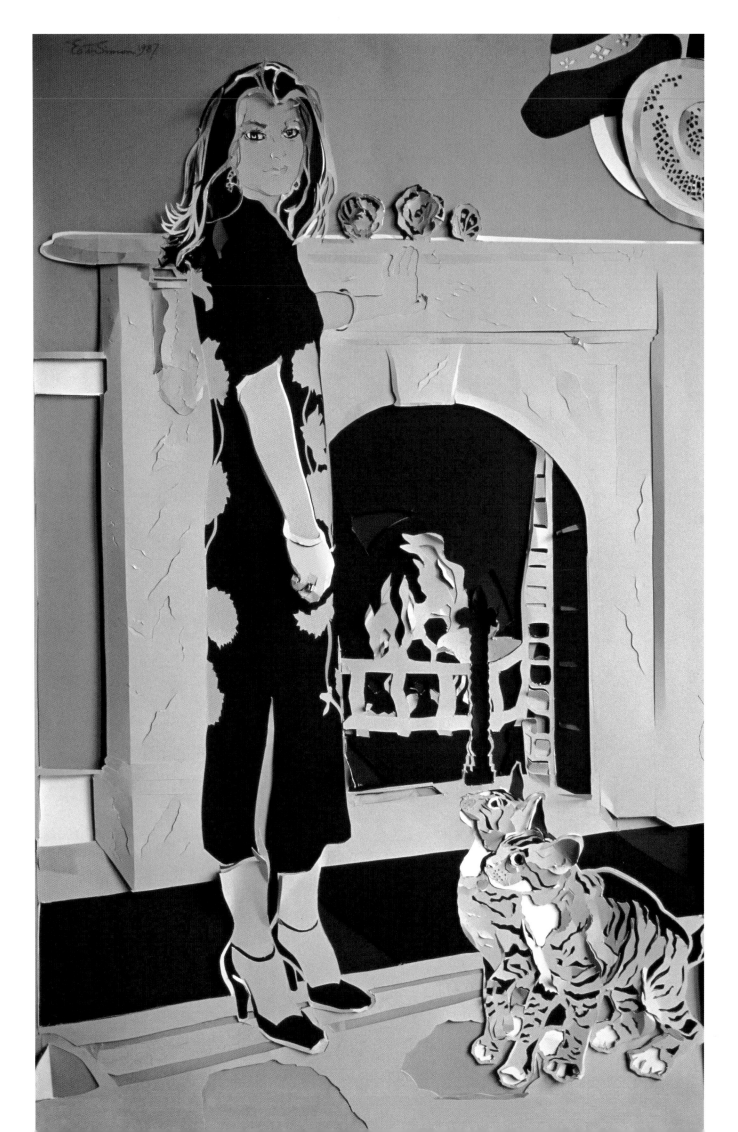

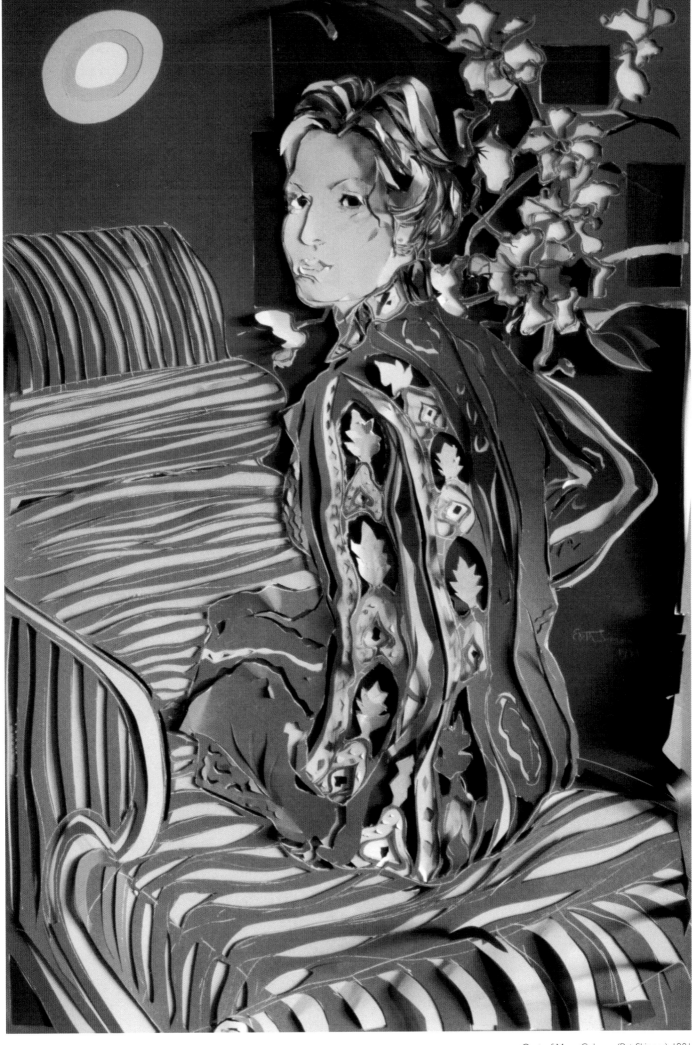

Coat of Many Colours (Pat Skinner) 1981
scalpel-painting five colour layers 36 x 24ins

Two Sisters: Deirdre (Deirdre Brittain) 1987
scalpel-painting six colour layers 36 x 23ins

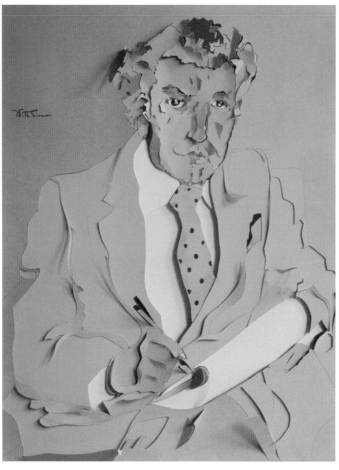

Coia (Emilio Coia) 1987
scalpel-painting six colour layers 30 × 27ins

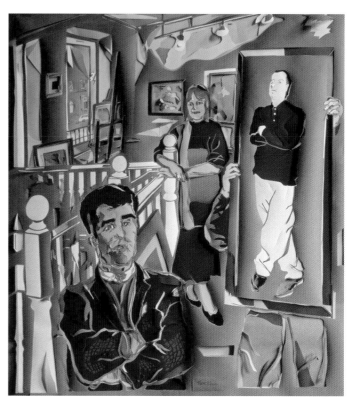

Gallery (Guy Peploe, Amanda Game, Robin McLure) 1993
scalpel-painting eight colour layers 44 × 40ins

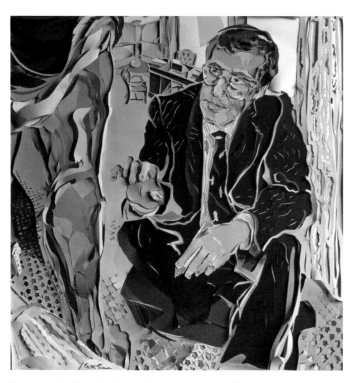

Surgeon in his Consulting Room (Mr A McL Jenkins) 1991
scalpel-painting nine colour layers 42 × 40ins

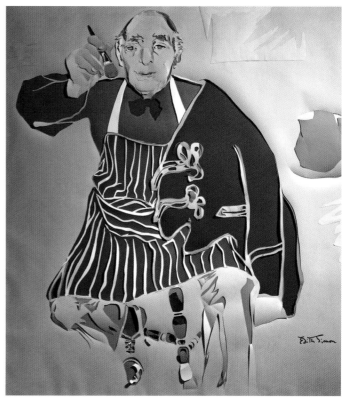

Brush Stroke (Alberto Morocco) 1994
scalpel-painting eight colour layers 40 × 39ins

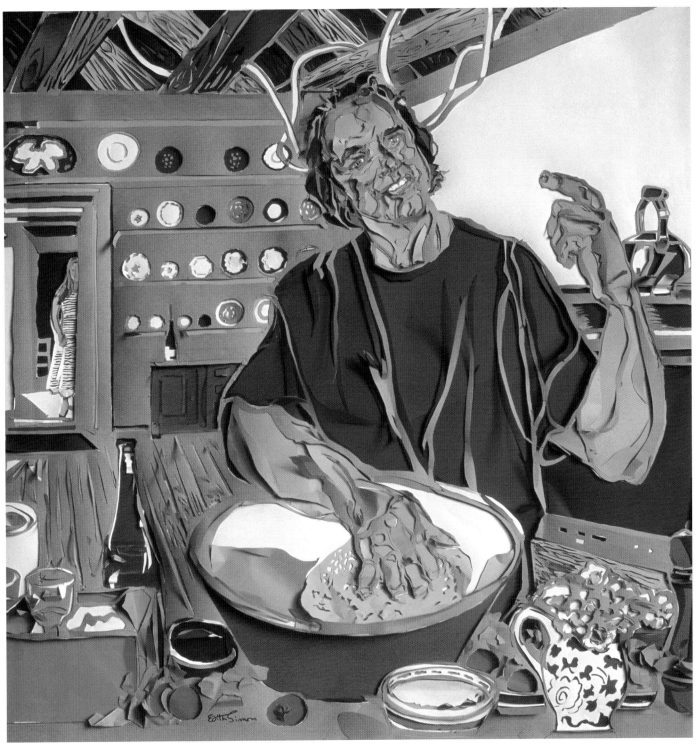

Still Life with Breadmaker (Derek Roberts) 1997
scalpel-painting ten colour layers 42 × 42ins

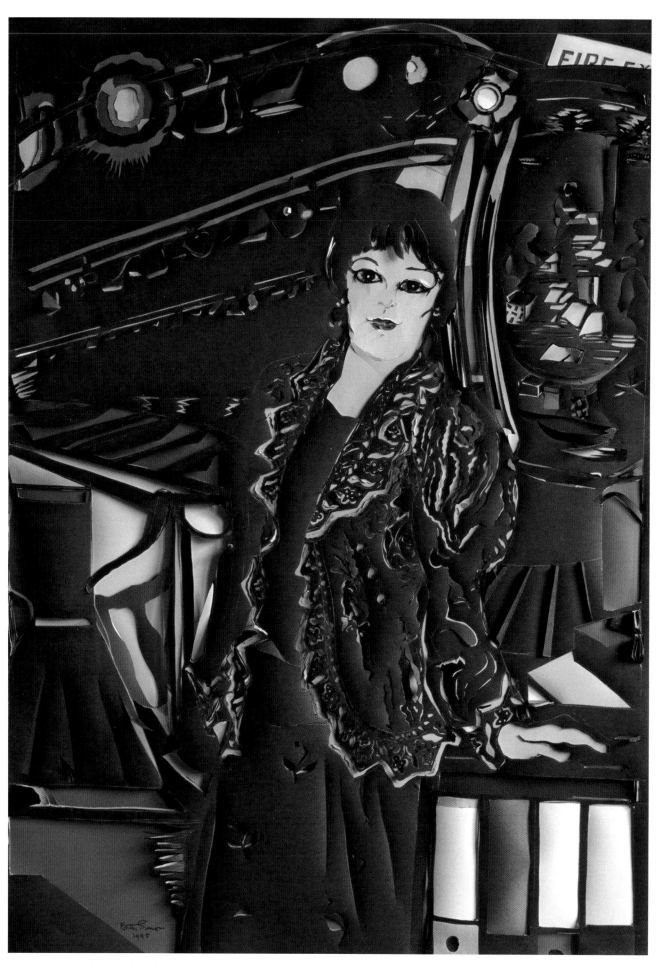

Hillary Strong at the Fringe Office (Hillary Strong) 1995
scalpel-painting nine colour layers 53 x 38ins

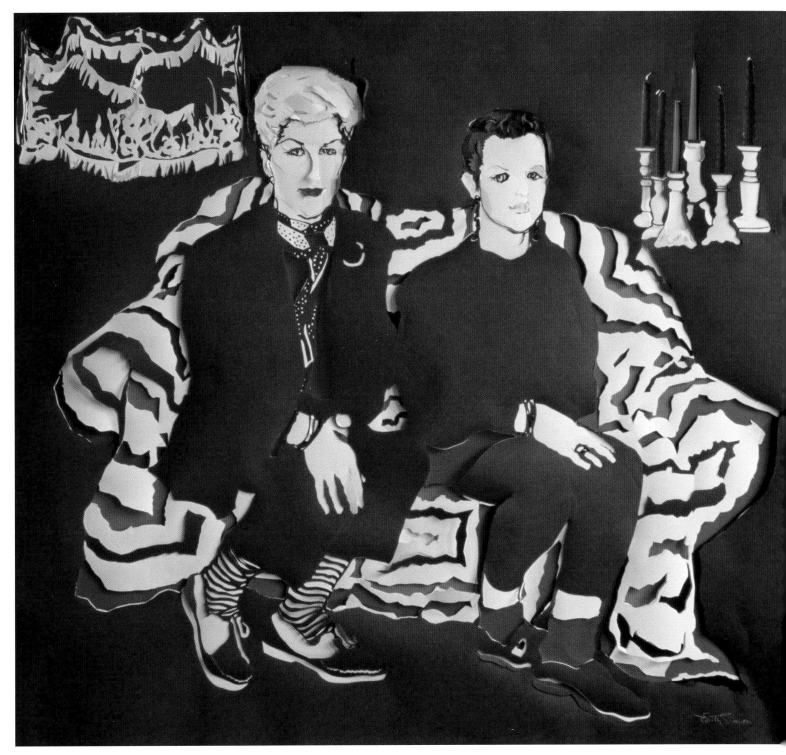

Double-Take (Myra and Louise Malcolm) 1991
scalpel-painting seven colour layers 39 x 43ins

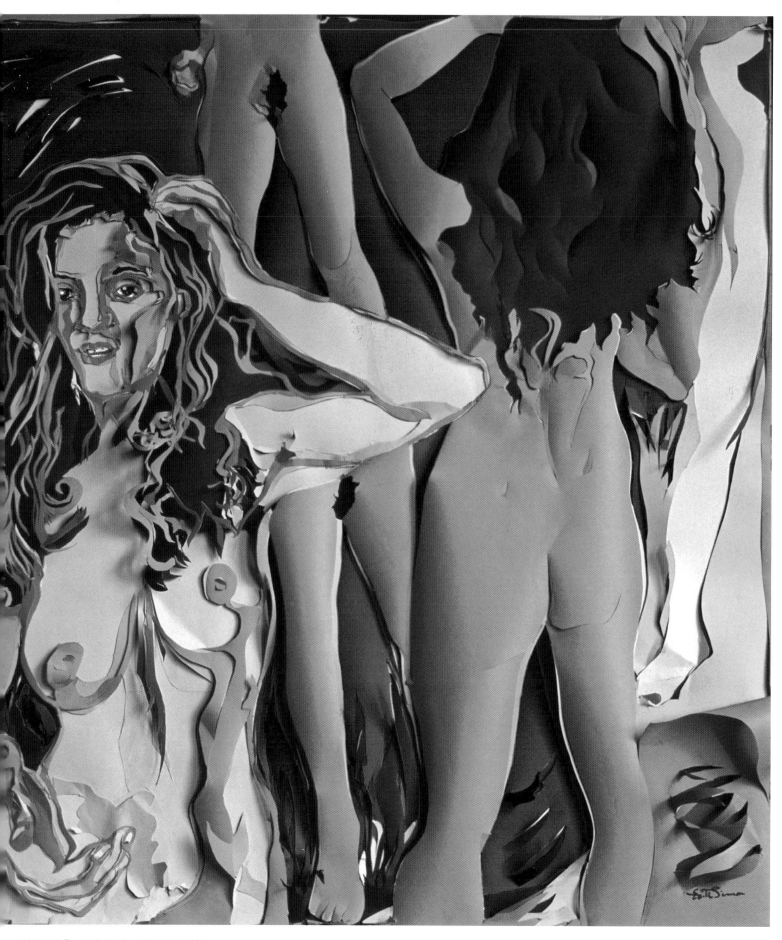

Hair, with Figures (Lala Meredith-Vuela) 1997
scalpel-painting seven colour layers 46 x 42ins

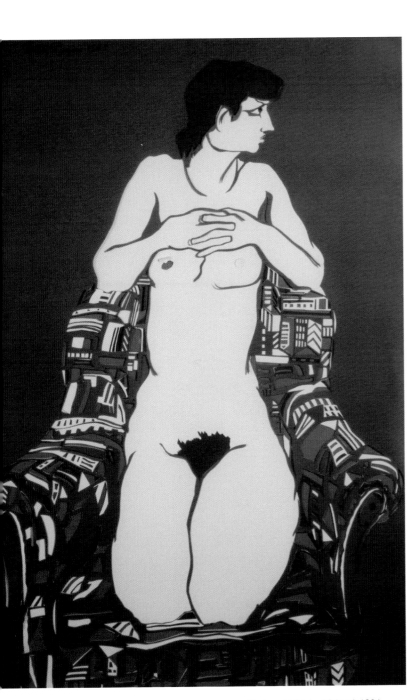

Cretan girl (Helen Vickers) 1984
scalpel-painting four colour layers 36 x 24ins

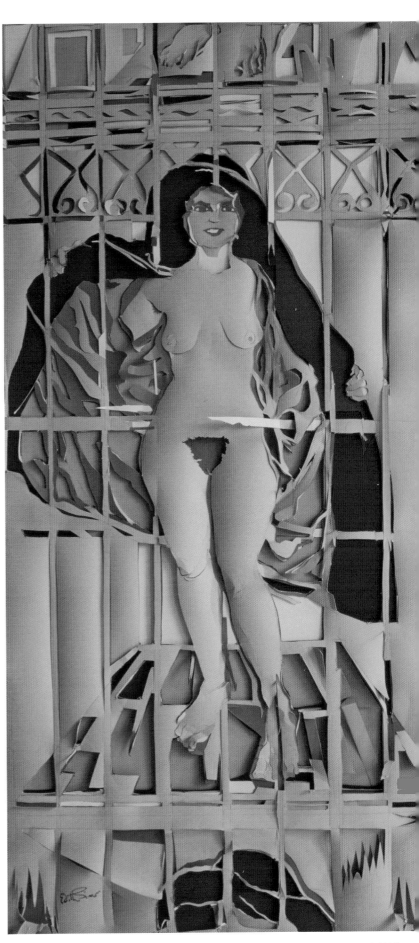

Flasher in Paternoster (Norah Elwell-Sutton) 1995
scalpel-painting six colour layers 40 x 20ins

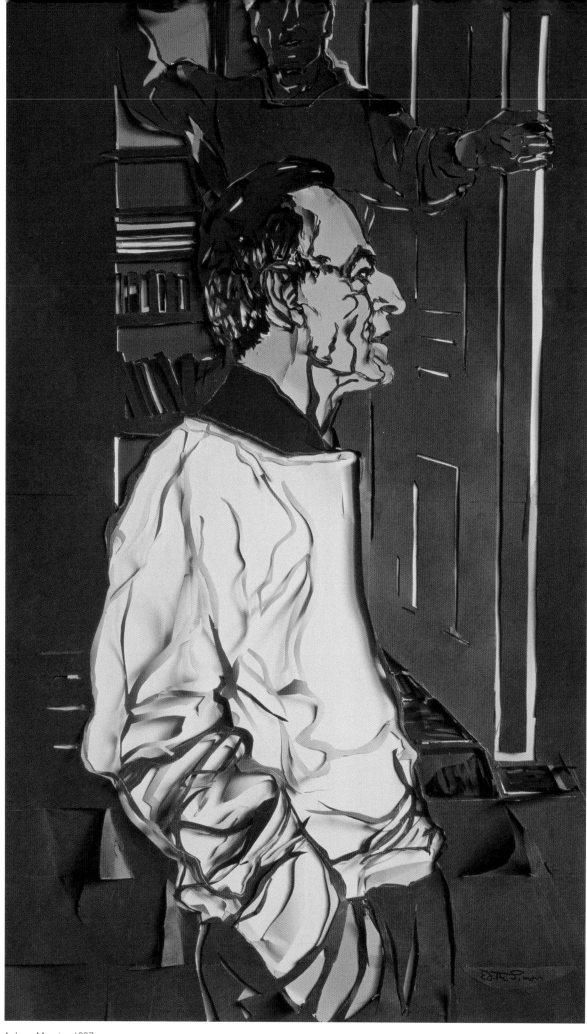

Aubrey Manning 1997
scalpel-painting eight colour layers 46 x 22ins

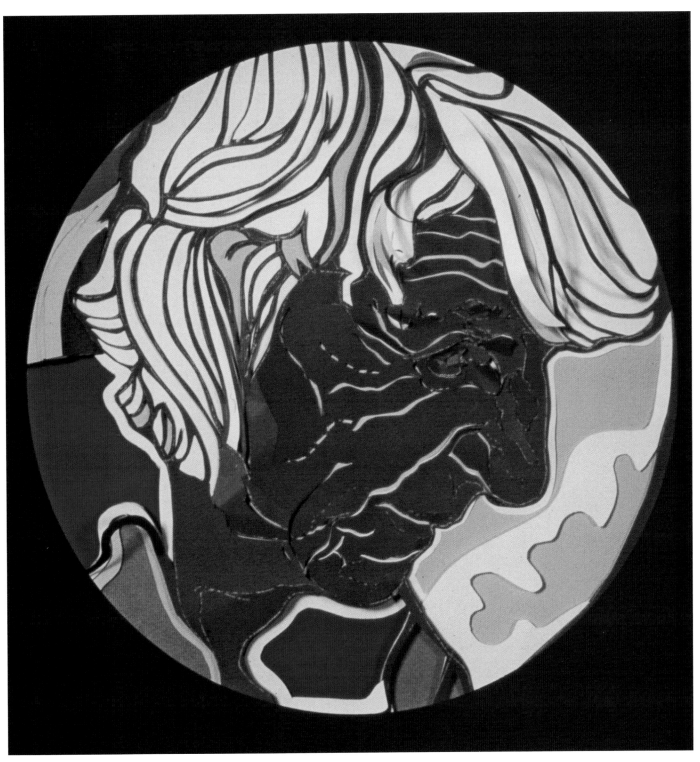

Map of a World (Naomi Mitchison) 1983
scalpel-painting five colour layers 12 x 12ins

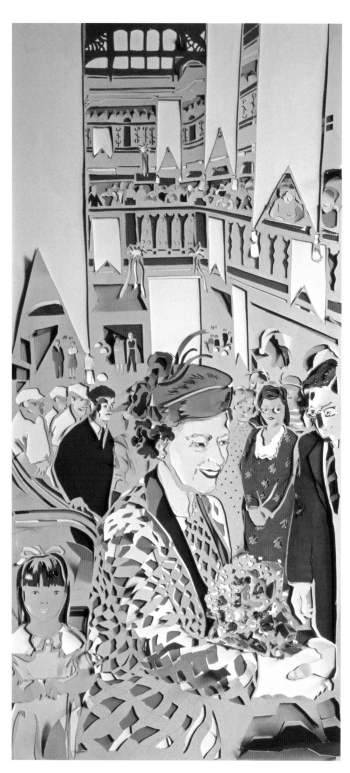

Handshake with Portrait (Queen Elizabeth II at Jenners, 150th anniversary) 1988
scalpel-painting six colour layers 44 × 23ins

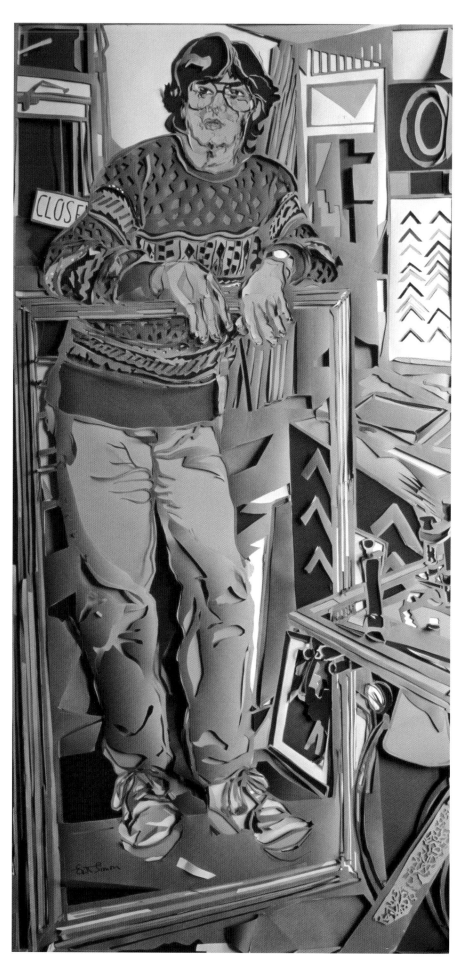

GR Framing (Gordon Robertson) 1992
scalpel-painting eight colour layers 78 × 42ins

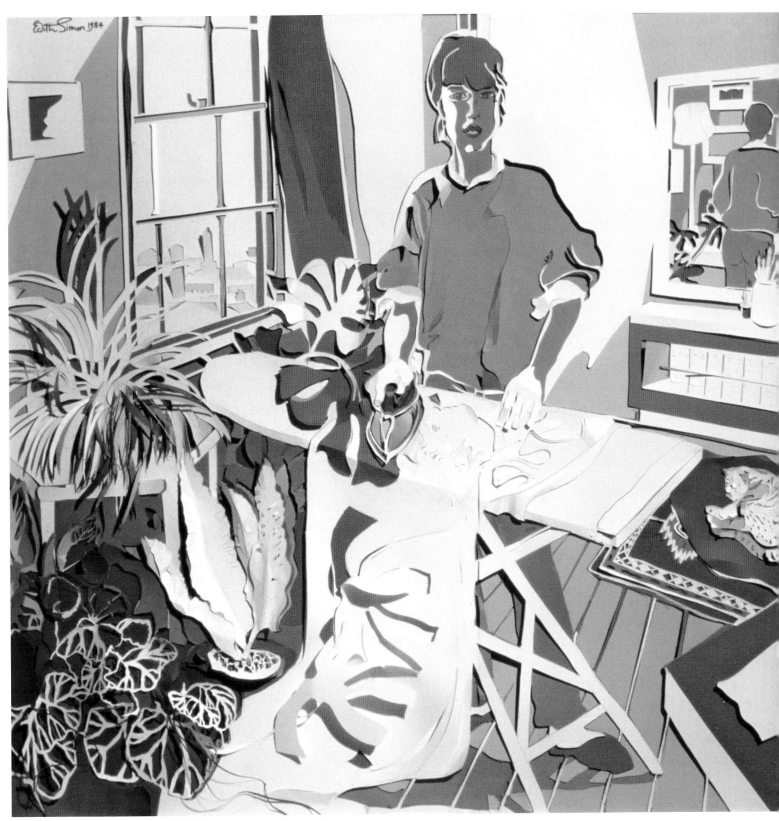

Silk Painter Ironing Her Plants (Caroline Blair) 1984
scalpel-painting seven colour layers 39 x 40ins

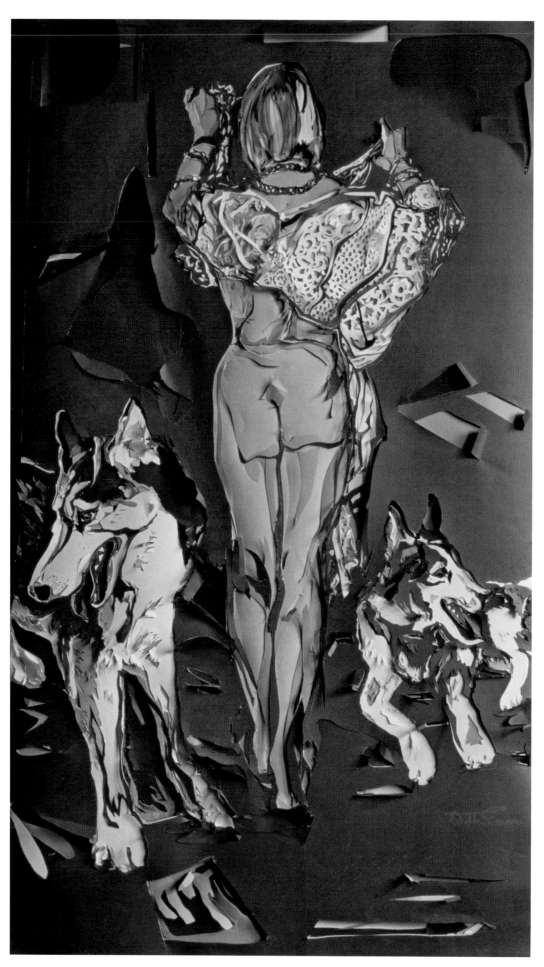

Catwalk (Janice Dickson and Huskies) 1998
scalpel-painting eight colour layers 48 x 28ins

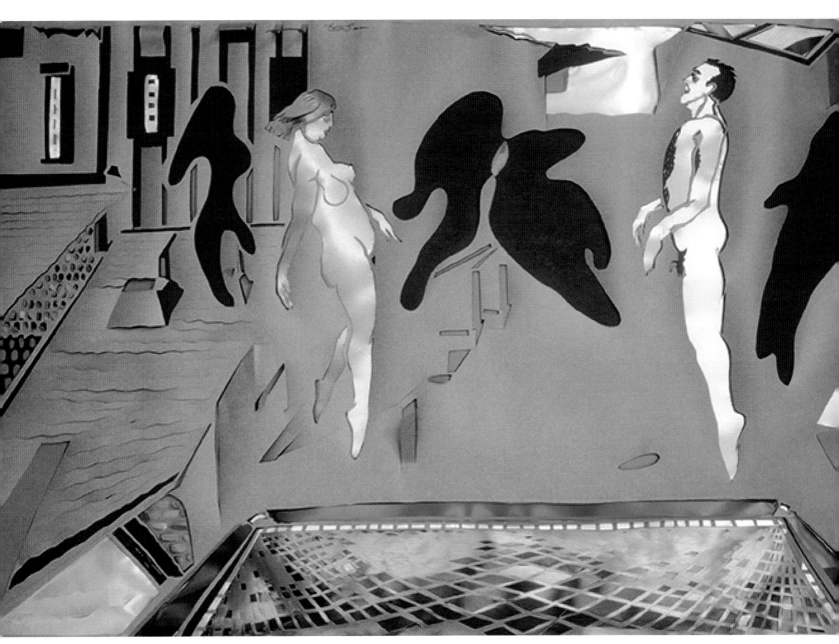

Matrimonial Trampoline 1991
scalpel-painting seven colour layers 36 x 24ins

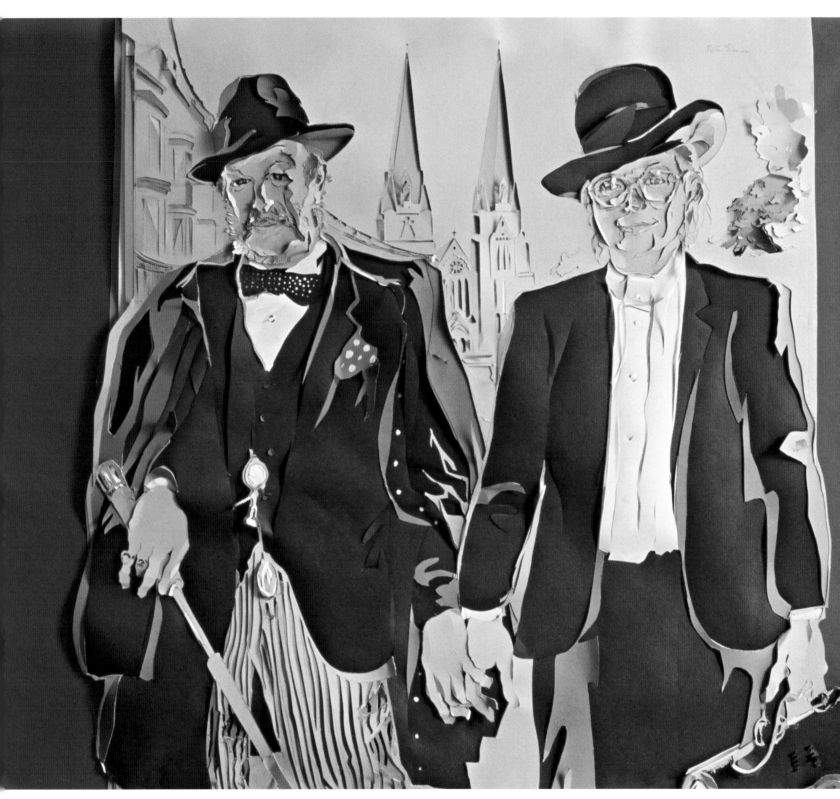

D R Robertson QC and Daphne Robertson QC 1987
scalpel-painting seven colour layers 42 x 53ins

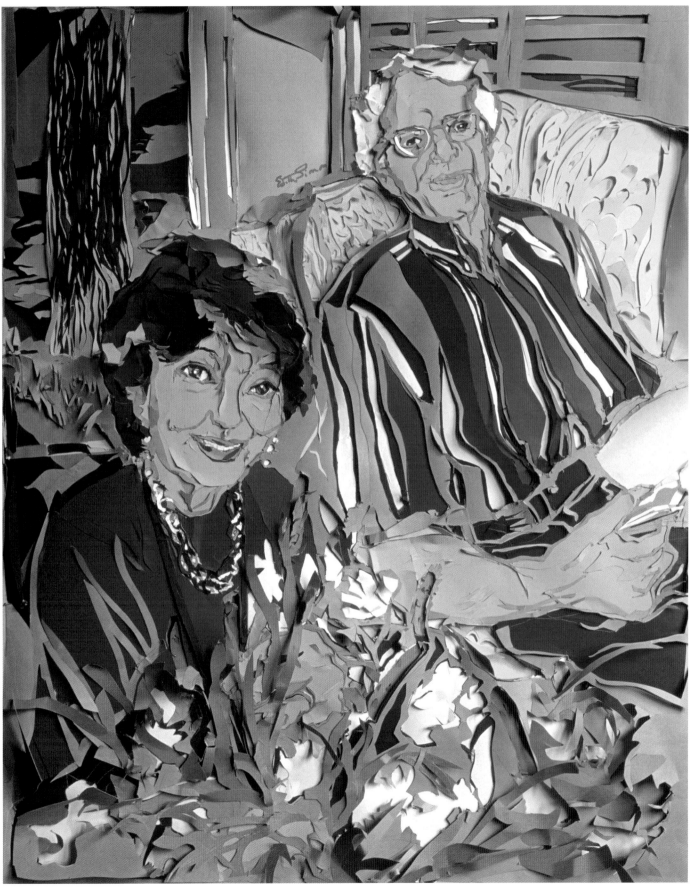

Jan and Dave MacKenzie 1999
scalpel-painting eight colour layers 42 × 35ins

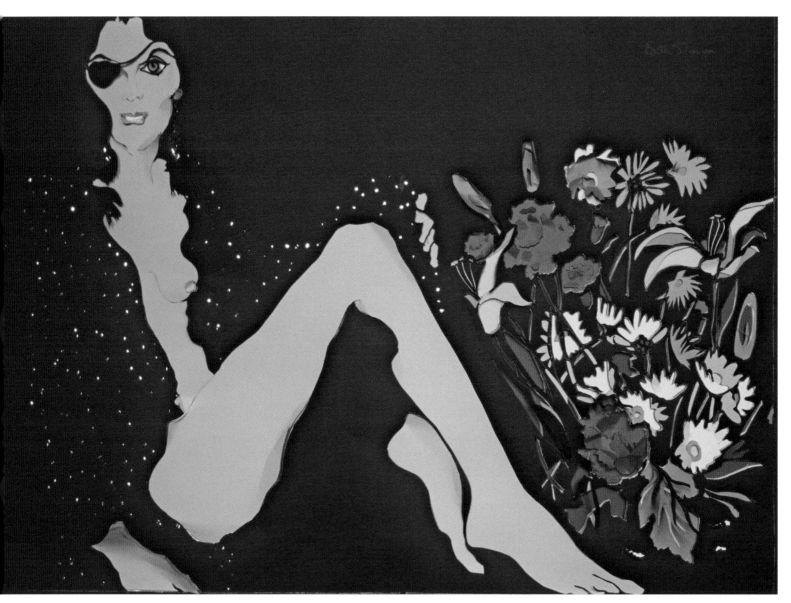

The Lady of Eboli (Isobel Roberts) 1989
scalpel-painting eight colour layers 30 x 44ins

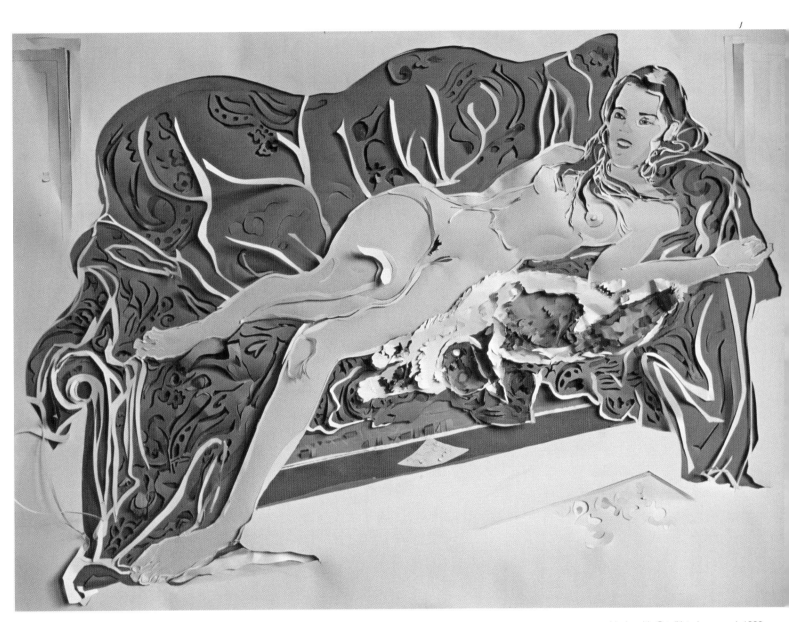

Nude with Cat (Katy Lawrence) 1999
scalpel-painting seven colour layers 51 x 45ins

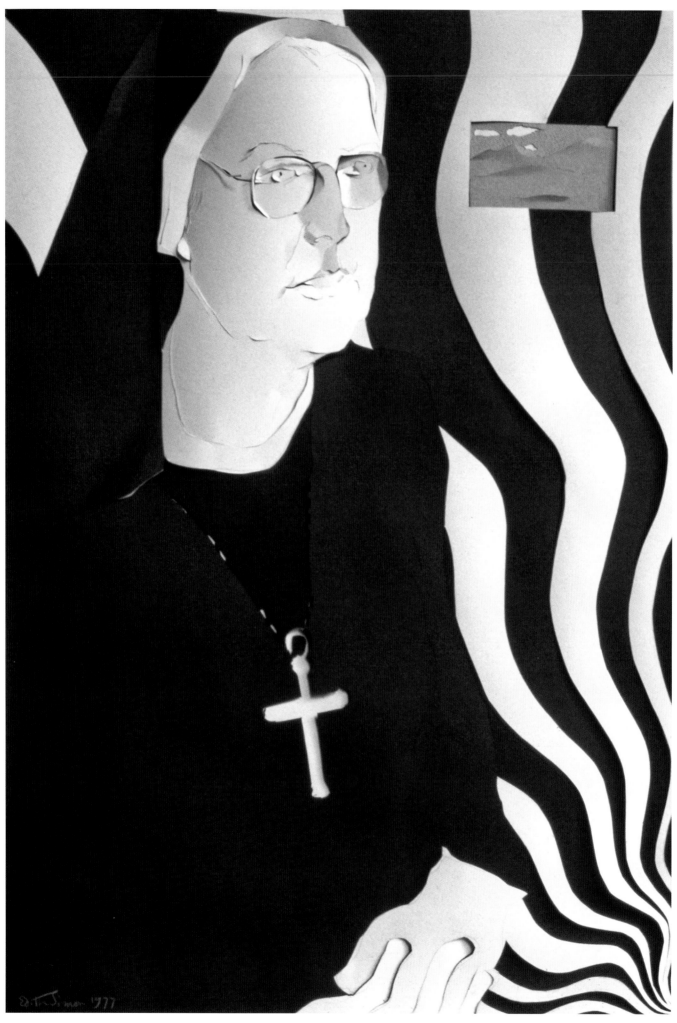

Reflections in a Cloister (Sister Ingles) 1977
scalpel-painting four colour layers 20 x 16ins

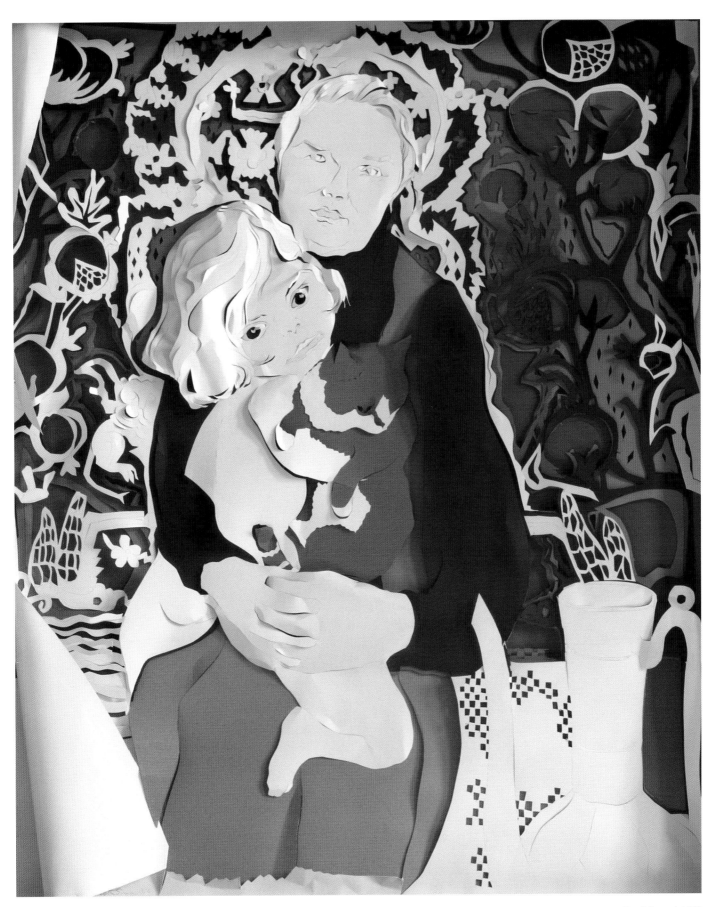

Mandorla (Alison and Nora Elwell-Sutton) 1975
scalpel-painting five layers 46 x 36ins

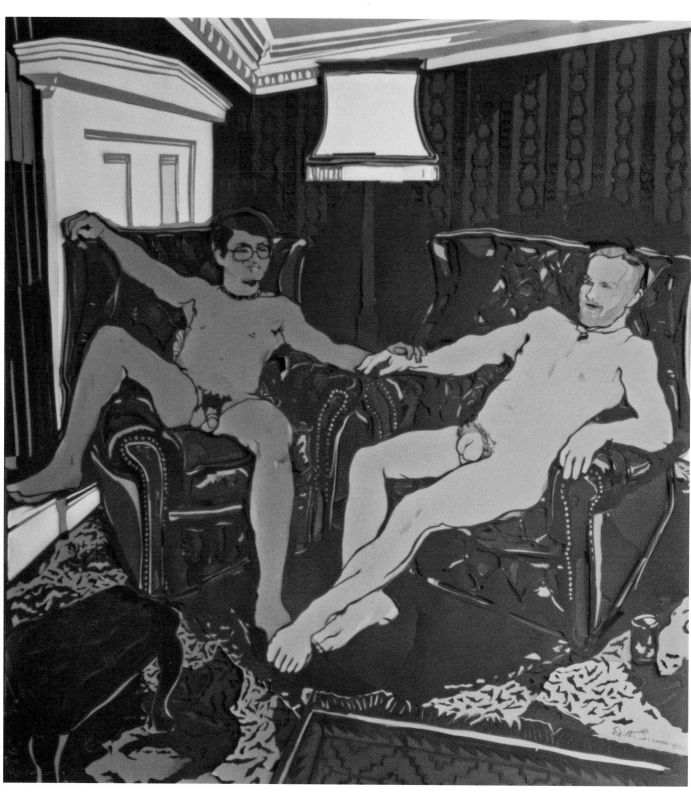

Drs Barsden and Tong 1982
scalpel-painting seven colour layers 54 x 42ins

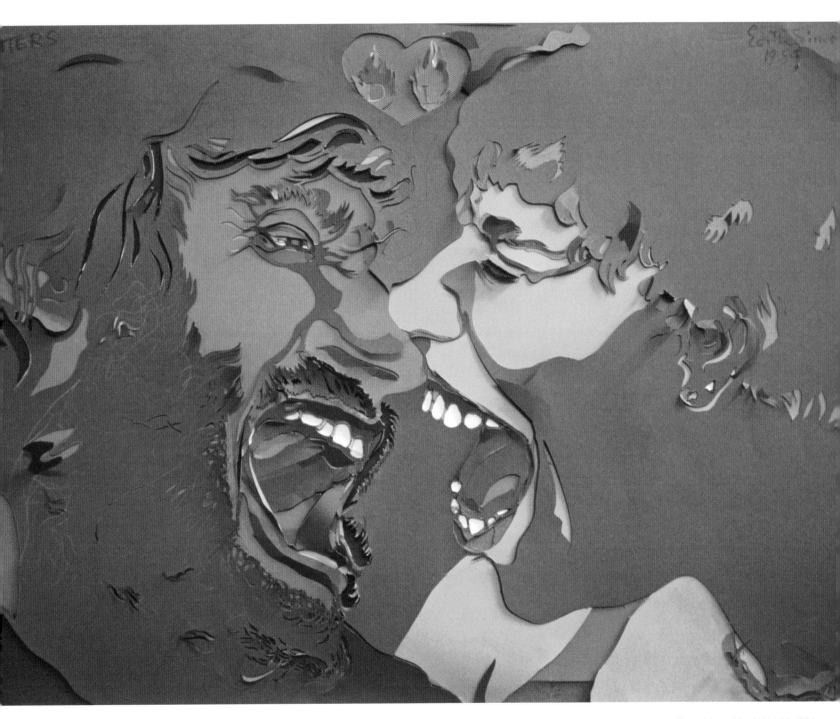

Biters (Liz and David Liddle) 1984
scalpel-painting seven colour layers 24 x 30ins

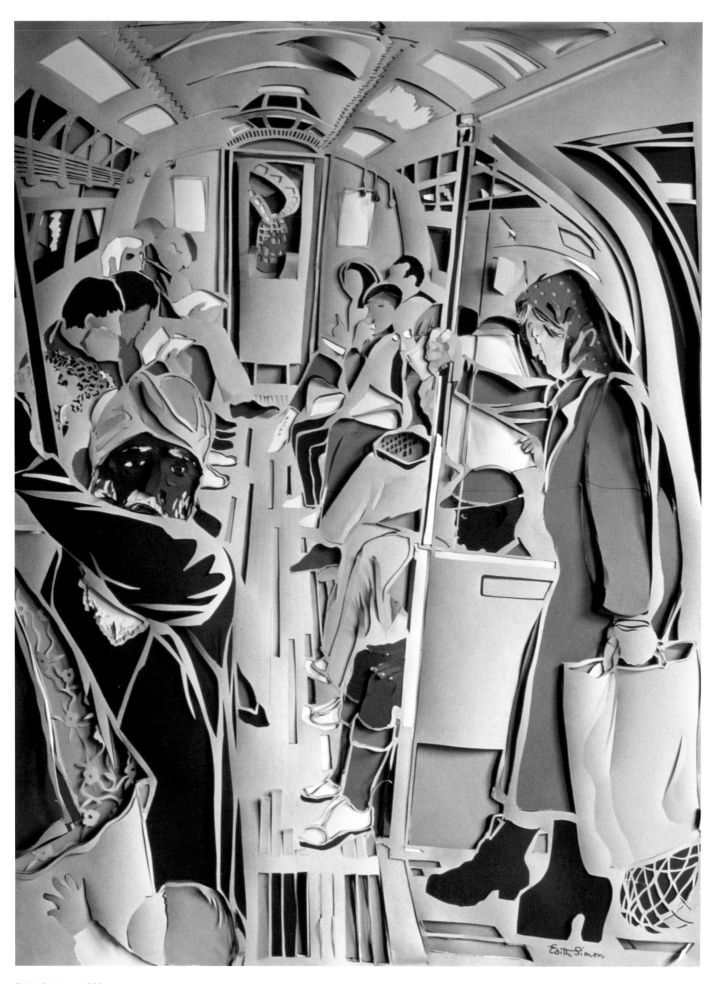

Public Relations 1988
scalpel-painting eight colour layers 49 × 37ins

These pictures are framed back to back.

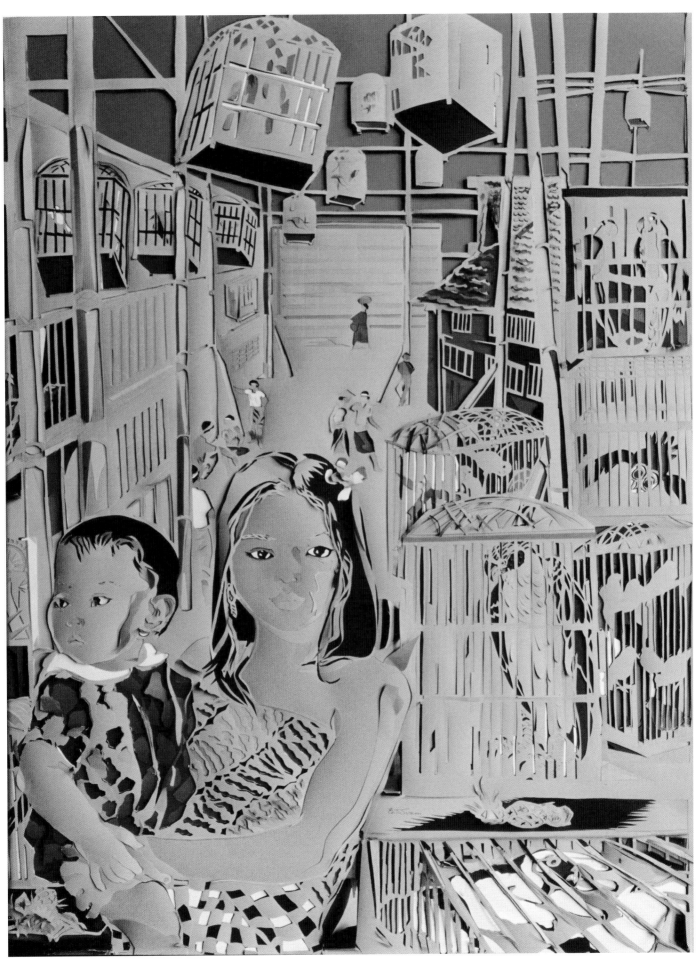

The Birdmarket 1988
scalpel-painting eight colour layers 49 x 37ins

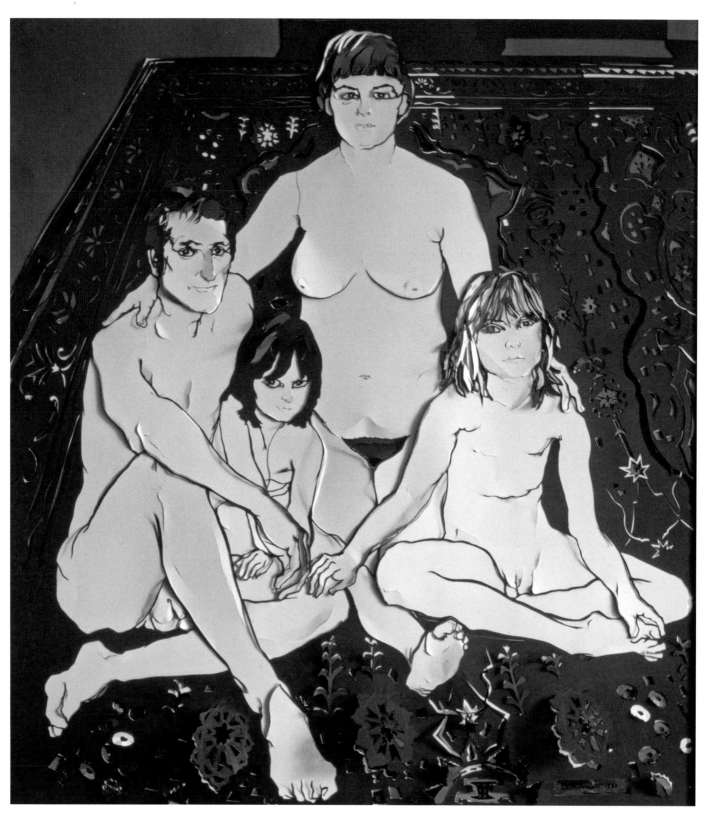

Flying carpet (Hillenbrand family) 1982
scalpel-painting five colour layers 36 × 36ins

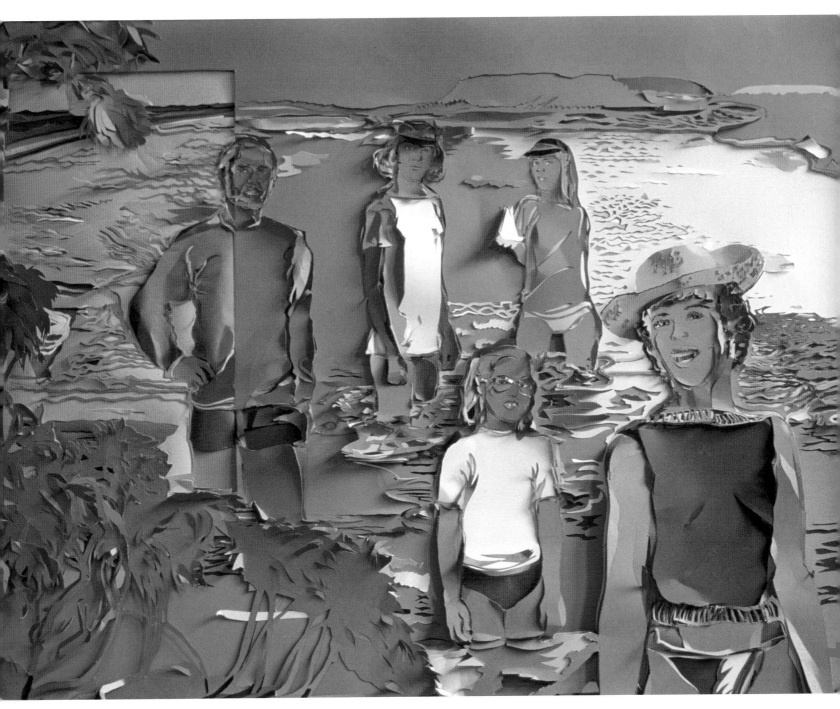

In the Sun (Willetts Family) 1985
scalpel-painting seven colour layers 34 x 45ins

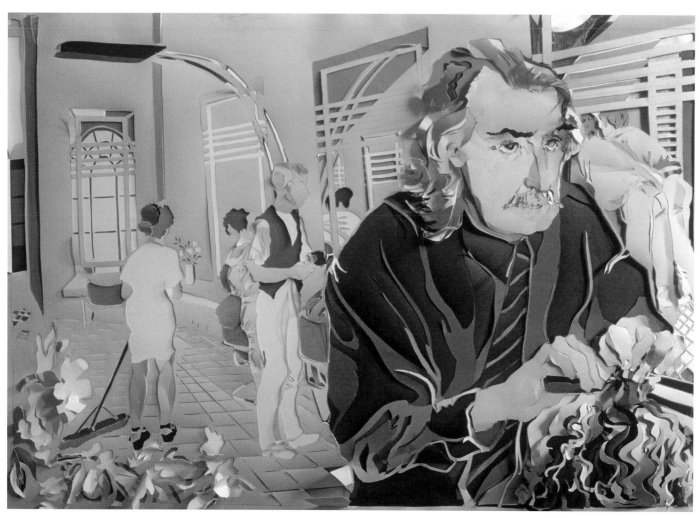

High Style (Charlie Miller) 1990
scalpel-painting six colour layers 43 x 26ins

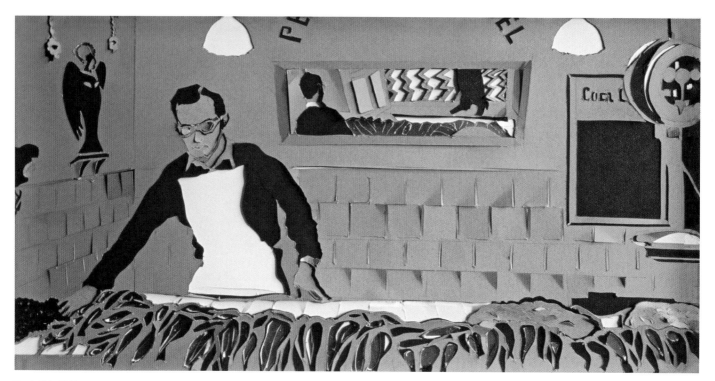

Fresh Fish 1984
scalpel-painting four colour layers 24 x 12ins

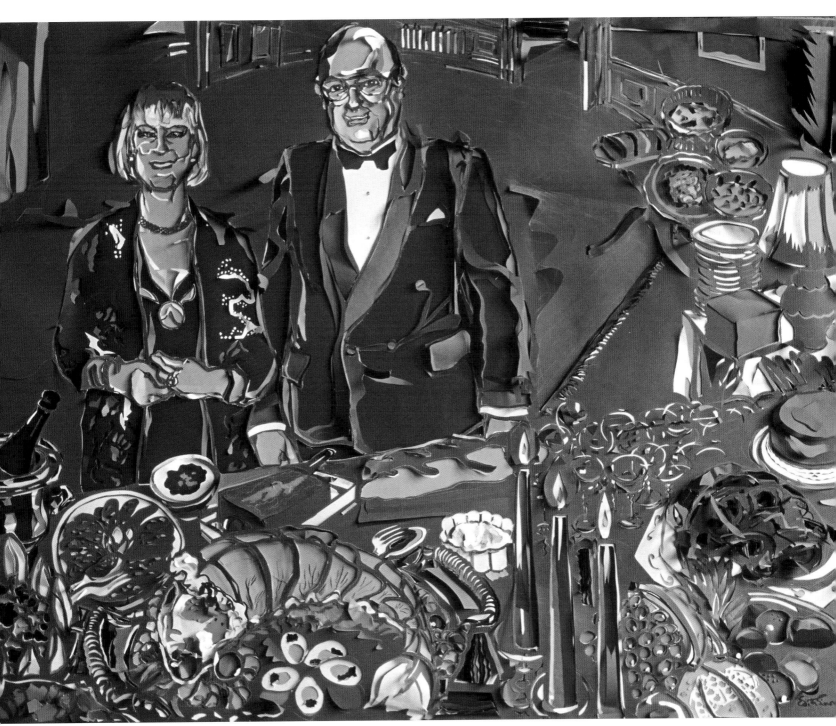

Tour de Force (Janice and Ian Dickson) 1994
scalpel-painting eight colour layers 54 x 44ins

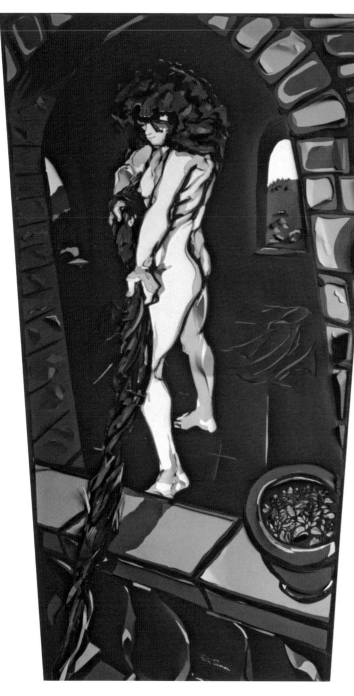

Rapunzel (Faye Yerbury) 1993
scalpel-painting eight colour layers 48 × 28ins

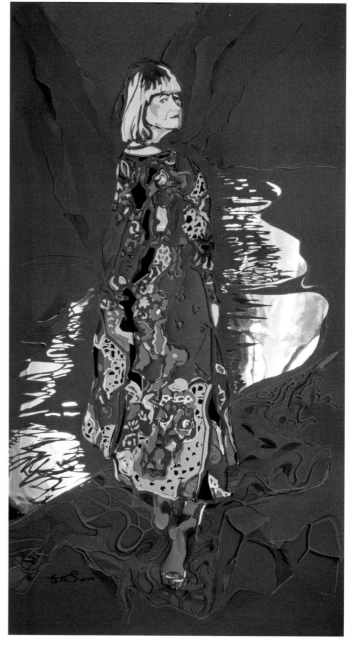

Chinoiserie (Janice Dickson) 1996
scalpel-painting eight colour layers 45 × 26ins

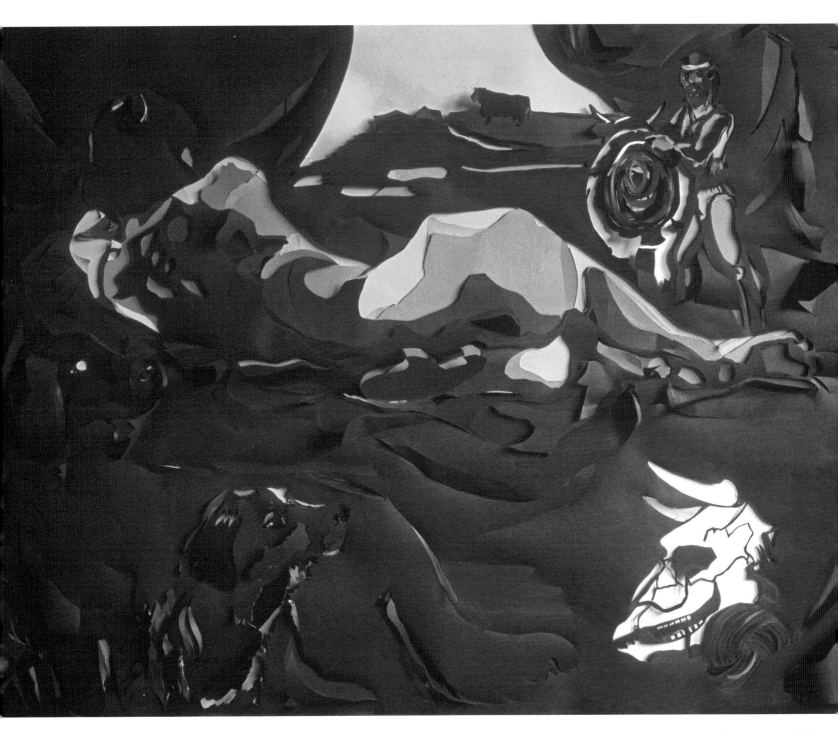

Daedalus giving the Cow to Pasiphae 1988
scalpel-painting seven colour layers 34 x 48ins

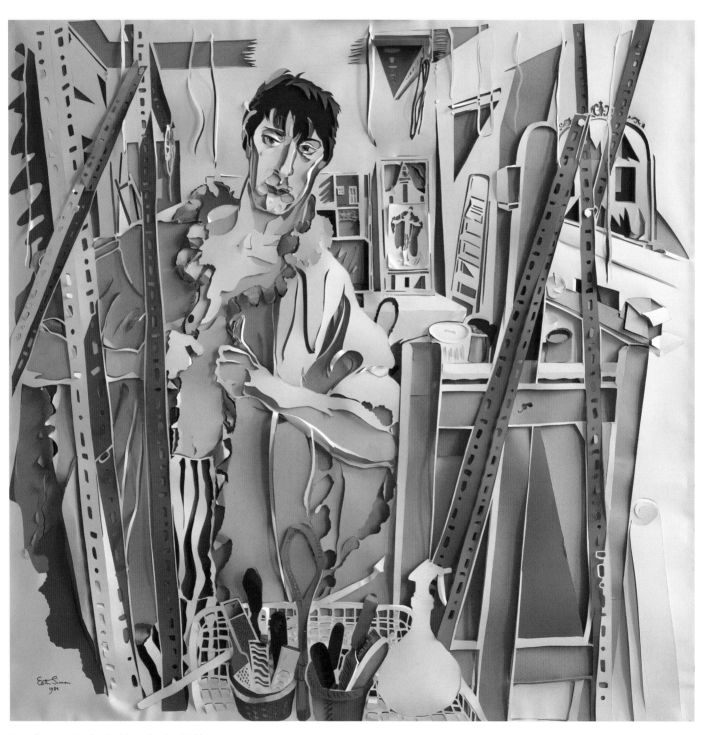

Kinny Posing in the Studio (Kinny Gardiner) 1984
scalpel-painting seven colour layers 48 × 48ins

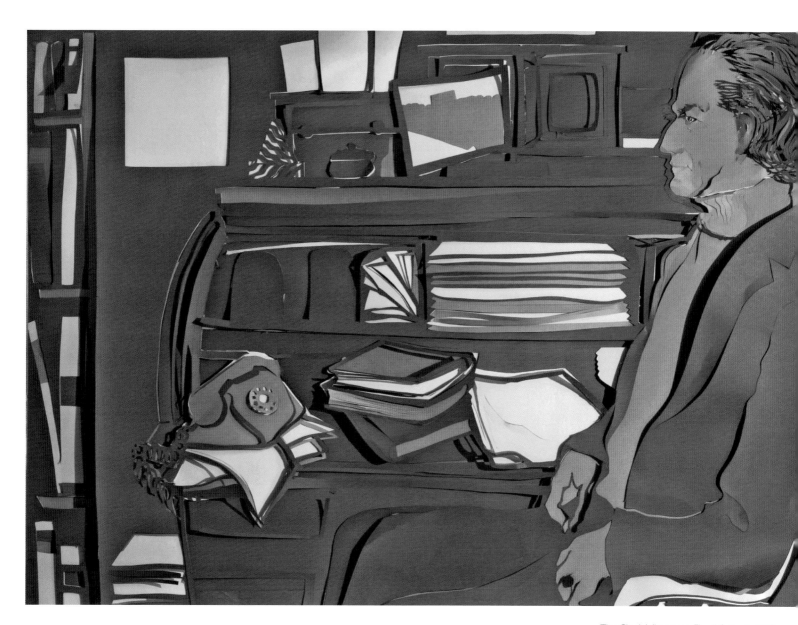

The Citadel (Laurence Elwell-Sutton) 1978
scalpel-painting five colour layers 25 x 36ins

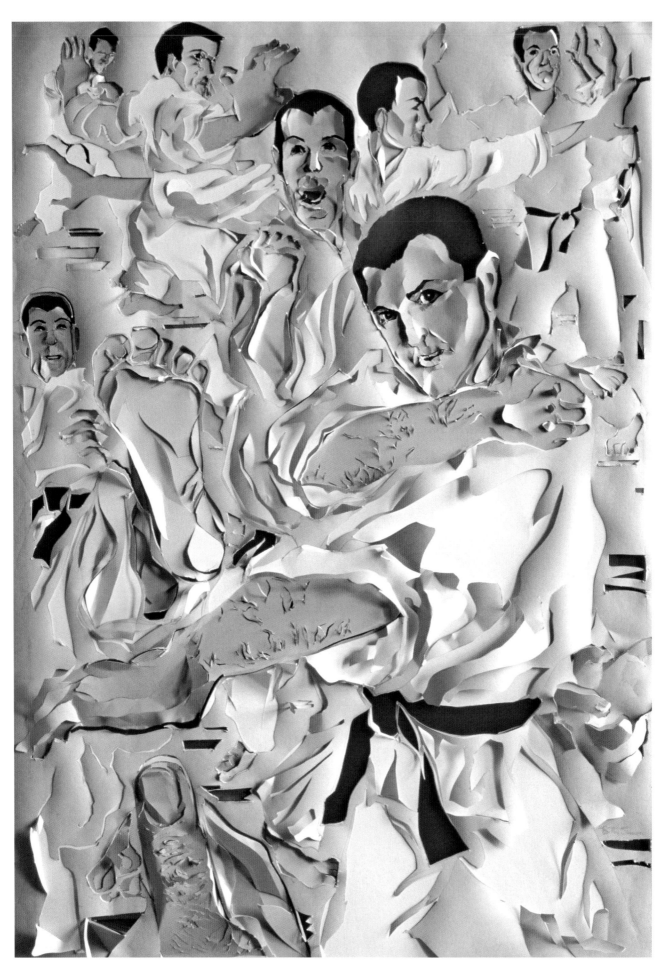

Karate (Dirk Robertson) 1990
scalpel-painting seven colour layers 36 x 26ins

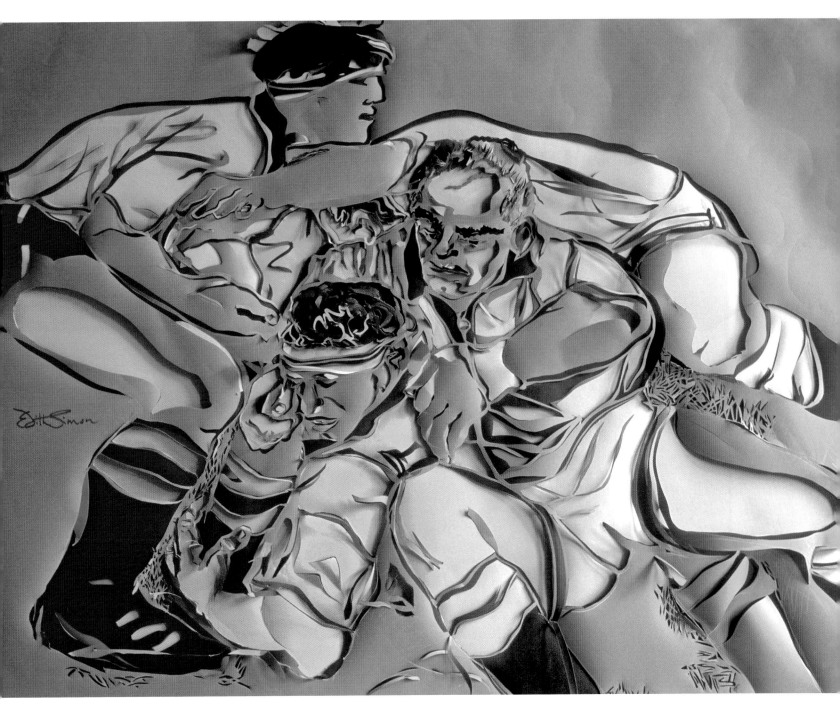

Scrum 1995
scalpel-painting six colour layers 51 x 68ins

Preparing Beans 1997
scalpel-painting five colour layers 11 × 13ins

The Waiting Basket 1983
scalpel-painting four colour layers 24 × 12ins

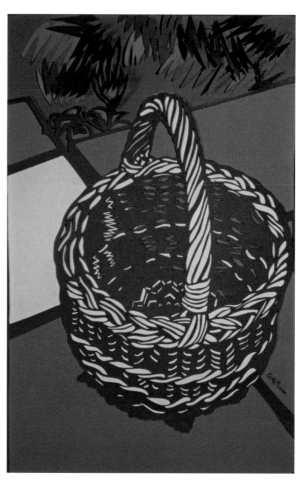

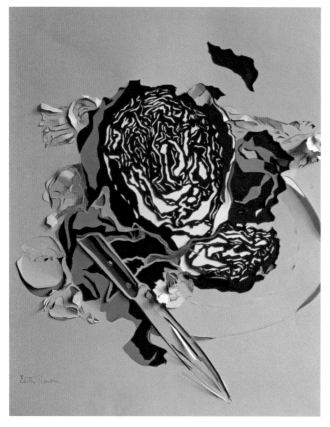

Red Cabbage 1991
scalpel-painting five colour layers 24 × 20ins

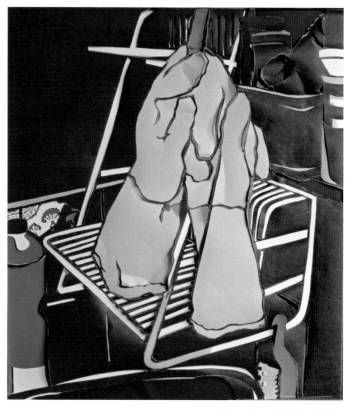

Kitchen Gloves No Hands 1989
scalpel-painting five colour layers 16 × 14ins

Simple Situation and Complicated Pattern (Elwell-Sutton Cats) 1993
scalpel-painting seven colour layers 39 × 34ins

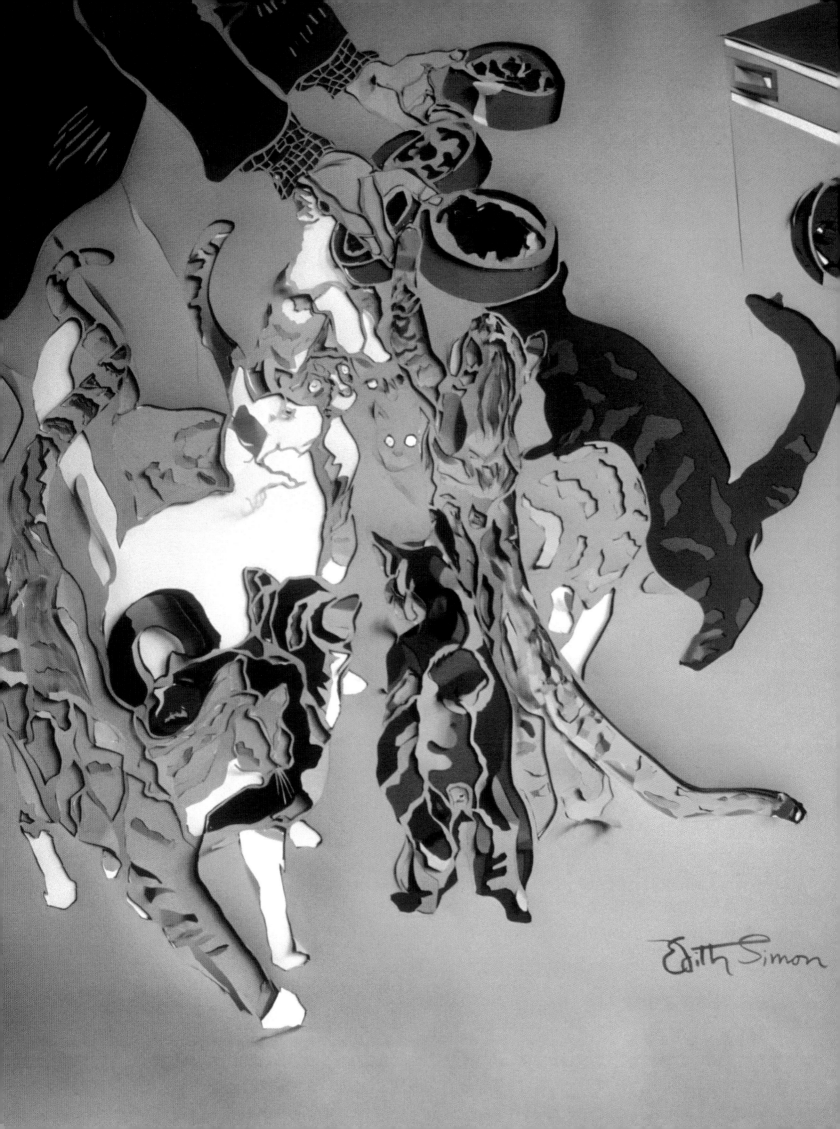

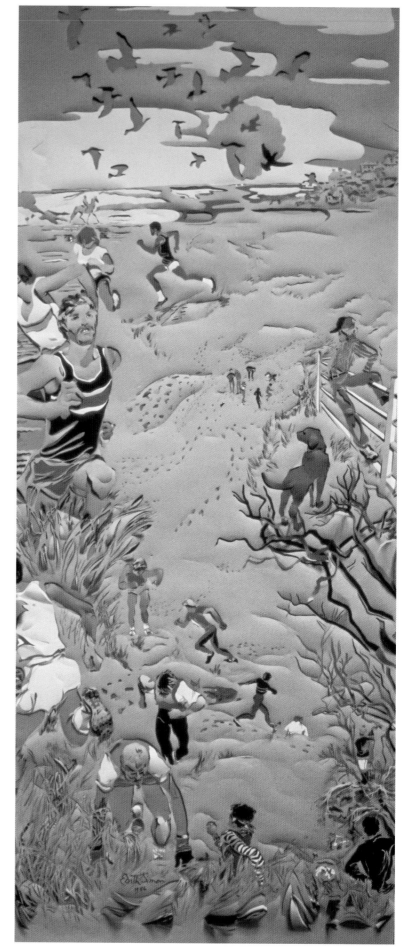

Runners 1986
Lammermuir House, Dunbar
mural including life-size sculpture
nine colour layers 180 x 72ins

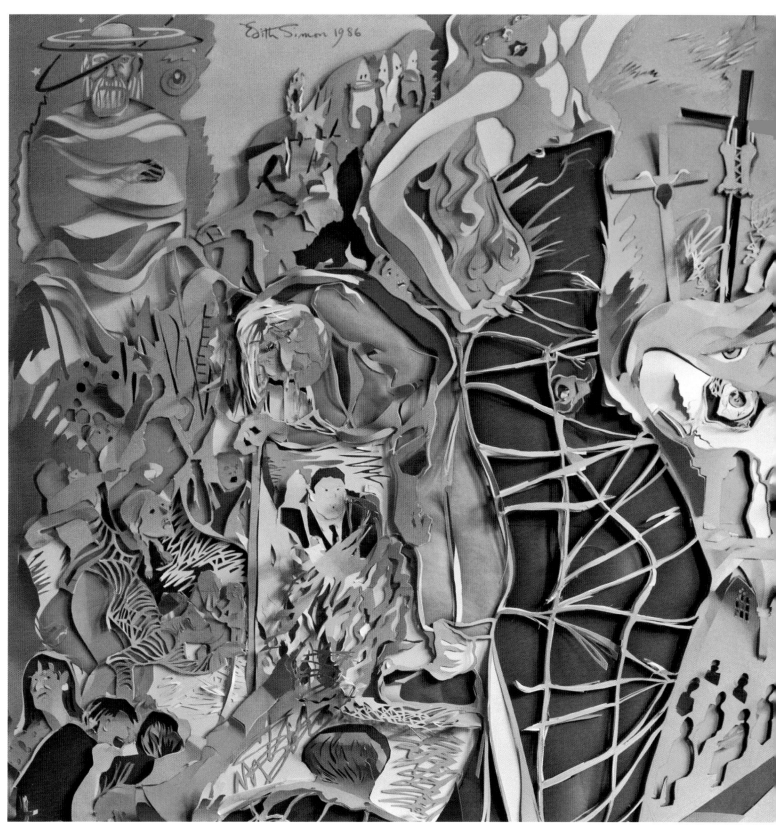

The Crime of Old Age 1986
scalpel-painting seven colour layers 48 x 48ins

Conductor (Neville Garden) 1980
42 x 36ins

Coppelia 1974
48 x 36ins

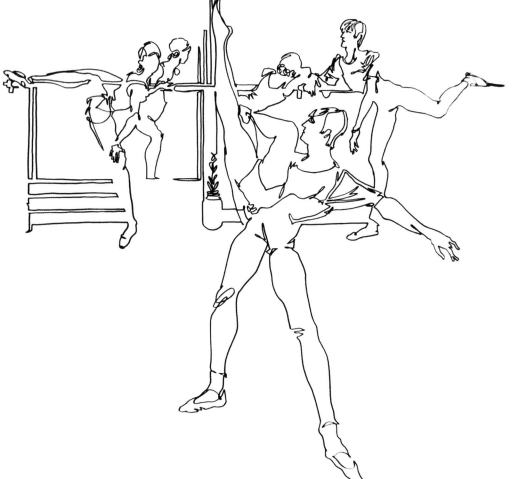

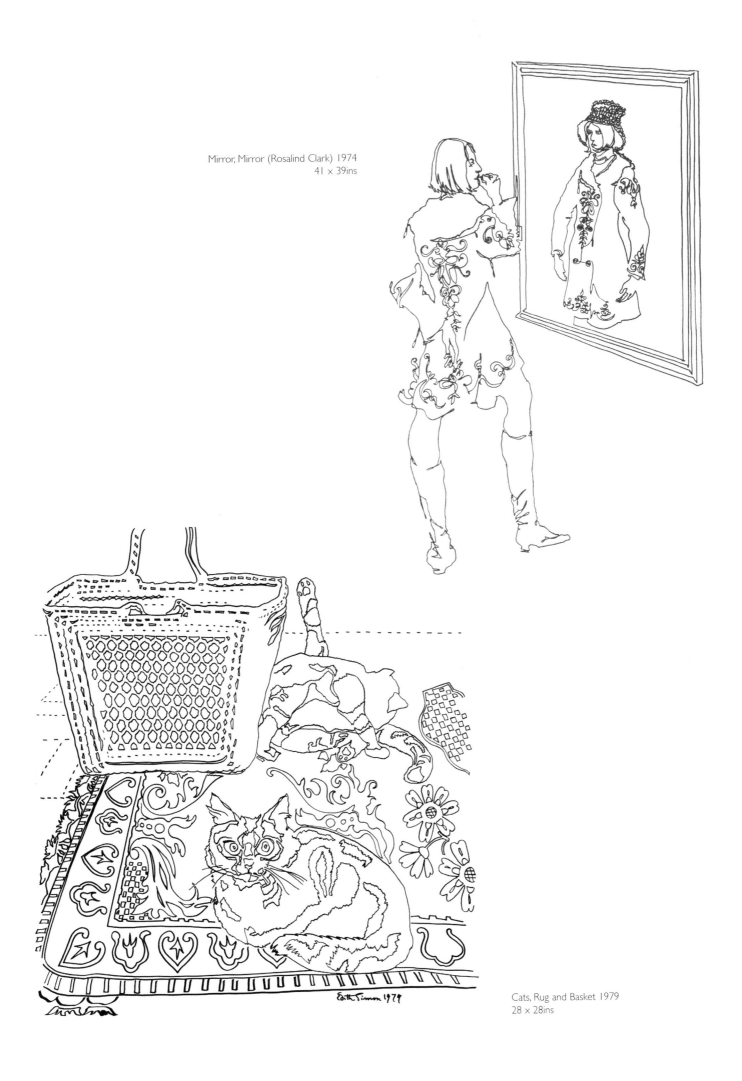

Mirror, Mirror (Rosalind Clark) 1974
41 x 39ins

Cats, Rug and Basket 1979
28 x 28ins

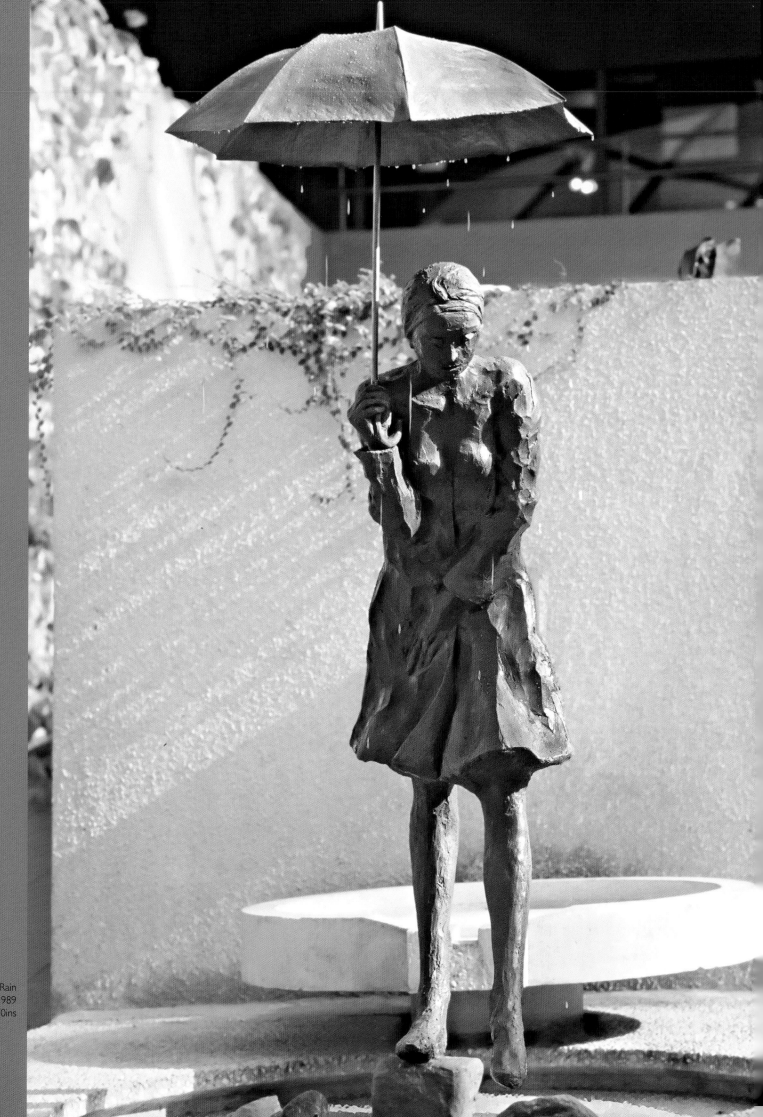

Woman in the Rain
fountain 1989
resin bronze 70ins

SCULPTURES
& mobile sculptures

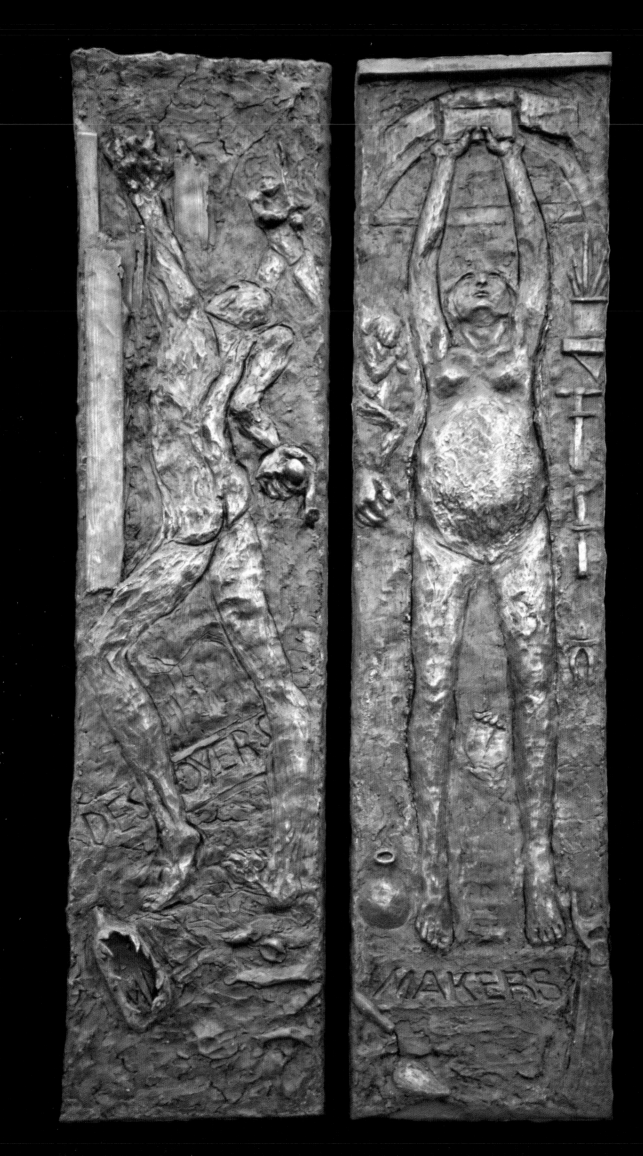

The Gates of Despair and Hope 1990
cold-cast bronze 81 x 30ins

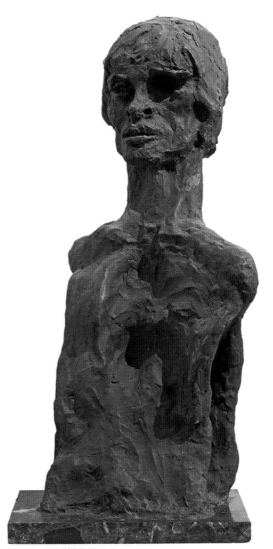

Nureyev 1975
cold-cast bronze 30ins

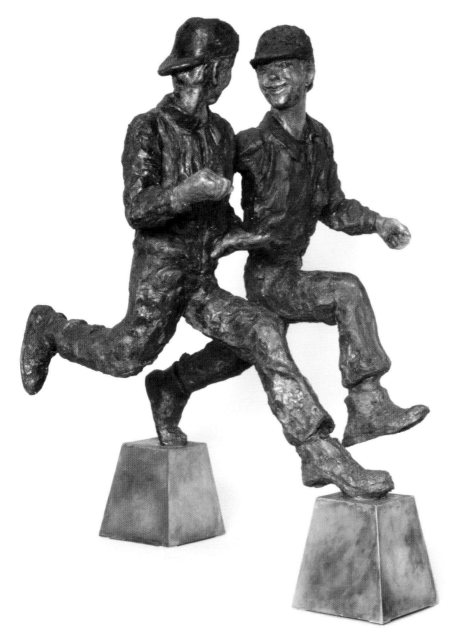

Boys, Running 1993
cold-cast bronze 48 x 38 x 42ins

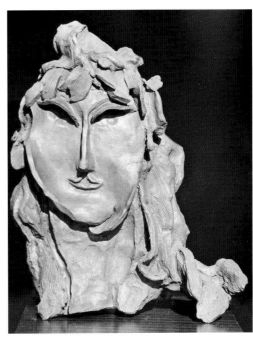

Lucy Cowan 1975
resin and fibreglass 15 x 10 x 4ins

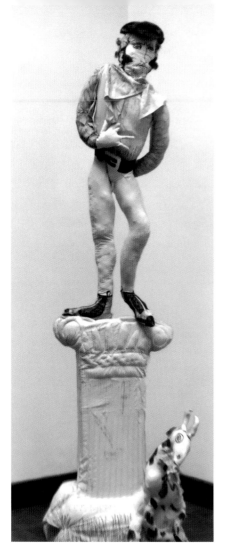

Richard Demarco 1970
96ins

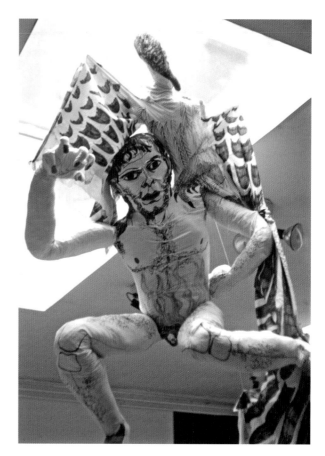

Prometheus 1970
72ins

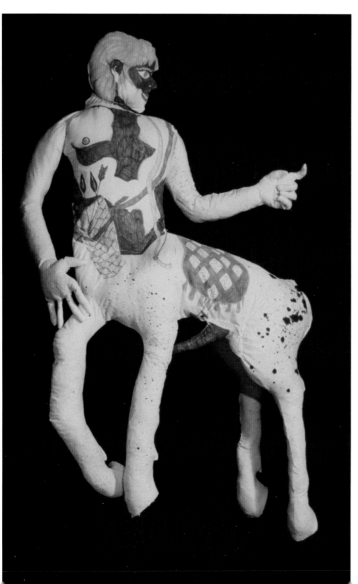

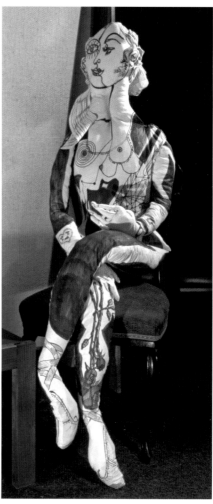

Ballerina 1970
80ins

Centaur 1970
72 x 72ins

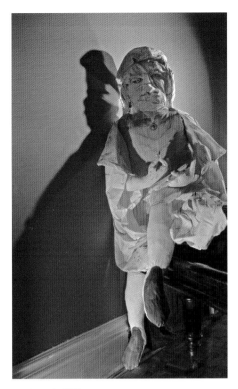

Rembrandt 1970
75ins

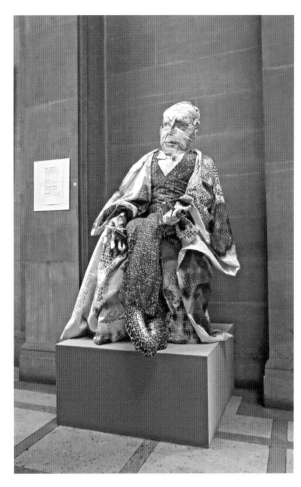

Sir Michael Swann 1970
80ins

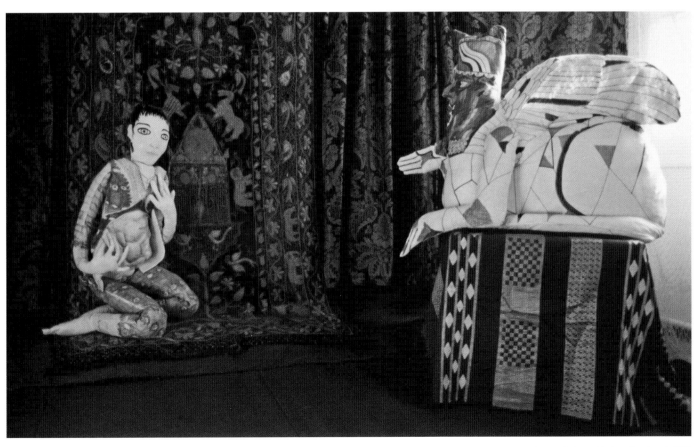

Annunciation with Assyrian Angel 1970
Virgin 60ins Angel 36 x 48ins

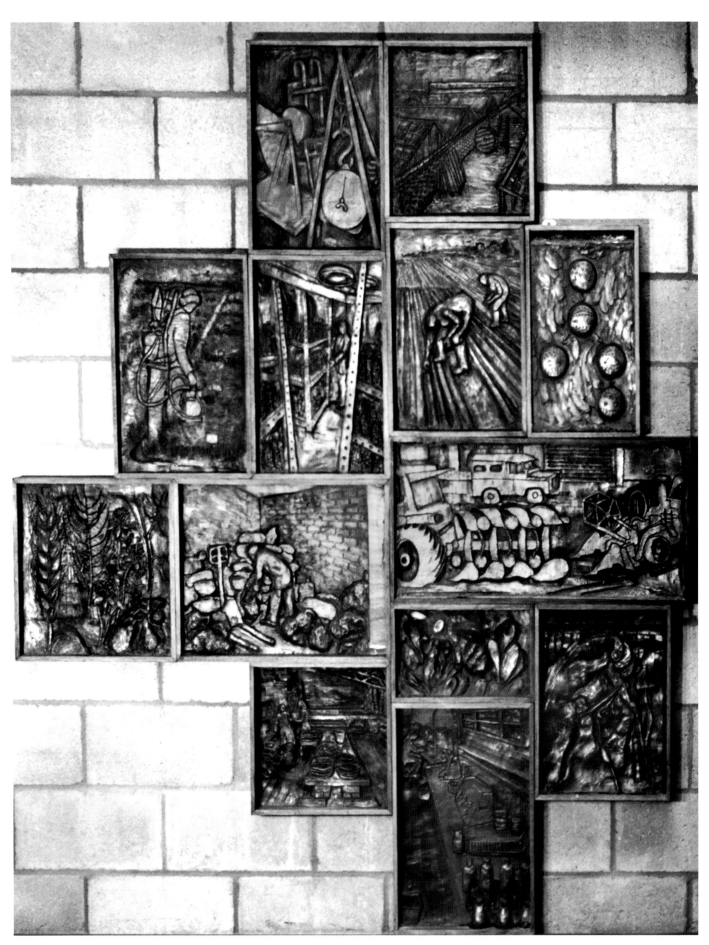

Biffen Memorial Panels showing work at the Plant Breeding Institute Cambridge 1980
cold-cast bronze relief panels 96 x 72ins

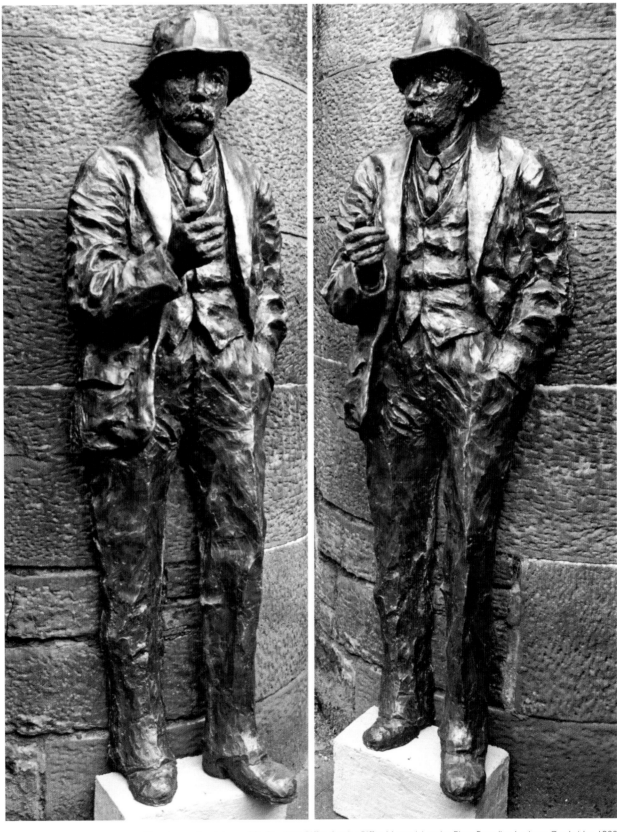

Two views of sculpture of Sir Rowland Biffen for the Biffen Memorial at the Plant Breeding Institute Cambridge 1980
cold-cast bronze 72 x 30 x 10ins